D1593199

Dirtdobber Blues

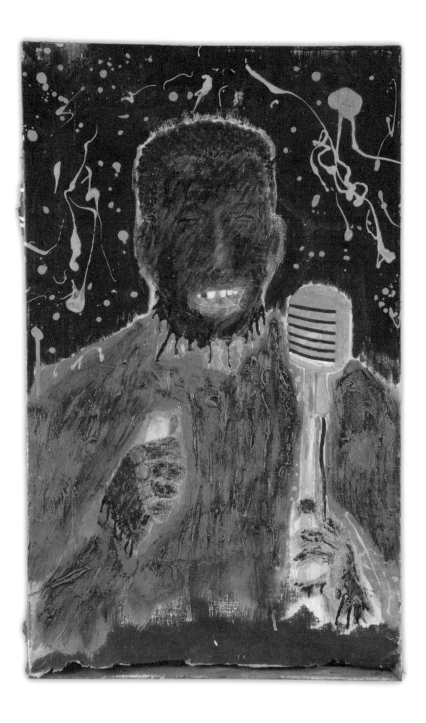

a novel

Cyril E. Vetter

Printed and Distributed by
LOUISIANA STATE UNIVERSITY PRESS

Copyright © 2011 by Cyril E. Vetter
All rights reserved
Manufactured in the United States of America
First printing

DESIGNER: Michelle A. Neustrom
TYPEFACES: Whitman, text; Centuryremixed 3, display
PRINTER AND BINDER: Moran Printing, Inc.

Frontispiece: Howlin' Wolf

LIBRARY OF CONGRESS CATALOGING-IN-PUBLICATION DATA

Vetter, Cyril E.
 Dirtdobber blues : a novel / Cyril E. Vetter.
 p. cm.
 ISBN 978-0-8071-3830-4 (cloth : alk. paper)
1. Blues musicians—Fiction. 2. Blues (Music)—Fiction.
3. Louisiana—Fiction. I. Title.
 PS3622.E89D57 2011
 813'.6—dc22
 2010038291
ISBN: 978-0-8071-3831-1 (e-book)

The paper in this book meets the guidelines for permanence
and durability of the Committee on Production Guidelines for
Book Longevity of the Council on Library Resources. ∞

Contents

Preface

THIS IS A ROMAN À CLEF, a work of "faction." Let's call it fiction based on some of the facts of the life of my dear friend, the late Charles "Butch" Hornsby. The story line roughly follows the narrative of Butch's life so in one sense it is biographical. But the characters are a combination of people who are totally made up and people who are real. The dialogue of the characters who are real people is made up, but I know them and their voices so well that I believe the things they do and say approximate what they really would have done or said.

A note to the real people who appear in this book: If I've put words into any of your mouths that you don't like or wouldn't have said, or if I've described you in a way or put you in a situation of which you disapprove, I apologize in advance. Think of it as literary license.

If you have issues with anything I say about myself, think of it as factual reportage!

And if I don't always show Butch in the best possible light, it's because I was trying to re-create the complicated, nuanced, talented, funny, tragic, lovable character he was.

I introduce most chapters with lines from Butch's songs. And throughout the book I've placed photographs of Butch in various settings and pictures of some of his art. His songs are on the CD in the back sleeve of the print version and are embedded in the e-book. If you listen to the music while reading the book, I believe it will enhance the experience.

Carol Hornsby, Butch's wife and the person who changed his life for the better, provided the intimate details of their life together and shared those details with me honestly and completely. She trusted me to tell Butch's story fairly and sympathetically. I hope I have earned her trust.

When Butch was drinking, he was a manic SOB. When he wasn't, he was a caring, loving husband and father and a great friend. Being a faith-filled woman, Carol doesn't like the language. But that's the way we talked then, and I want the dialogue to ring true.

Butch was a talented man. He was an actor, a poet, a singer, a songwriter, an artist—all the things creative people aspire to came easy to Butch. And observing his life over almost forty years, I never understood why he didn't experience more success. But for whatever reason—fear, disdain, inability to maintain focus, or his pose of just not giving a damn—Butch was not a commercial success while he was alive.

But I never lost faith in the power of his songs and their imagery and poetry. Even after forty years, I still sing to myself, "No, I ain't no matador, but now and then I have been gored. I ain't no chauffeur, but I can hold it in the road," or, "This week's been bleak, I don't know what I'm doin'. What we were, so fine and grand, what we are is ruin."

Cyril E. Vetter
Baton Rouge

Dirtdobber Blues

1

Believer in the Blues

This week's been bleak, I don't know what I'm doin'.
What we were, so fine and grand, what we are is ruin,
No poem or song sung could ever say how I feel,
Since that recent evenin', you said "I'm leaving"
Then you walked out on me . . .

I used to be a happy guy, always looking on the sunny side,
And you don't even realize . . . do you? Through you . . .
I became a believer in the blues.

THE TWELVE-YEAR-OLD BOY JUMPED OUT of the car at the country crossing and started running as fast as he could across the strawberry field. His target was a man on a tractor parked under a tree about a quarter mile away and a hundred yards to his right. "Butch, get back in here," his aunt Julia yelled after him. Pointless. He kept running, his progress measured by trampled berry plants. The tree offered the only shade in the 90-degree South Louisiana sun, and by the time the boy reached it, the old man was just cranking the tractor. Puffs of black smoke spewed from the vertical tailpipe, and the tailpipe cover rocked back and forth on its rusty hinge.

"'Manuel, 'Manuel!" the boy shouted over the din of the old tractor. "'Manual, stop the motor!" He tugged on the tractor driver's overalls.

"Whatchu want, Butch?" he said, turning off the ignition with an exaggerated display of impatience. "Whatchu want? I'm busy out here."

"Immanuel, when you gonna show me how to play the blues on a guitar?" the boy replied.

"Whatchu know about the blues?" he huffed in reply. "White folks don't sing the blues. You got to suffer to sing the blues, and I don' see too many white folks in Tangipahoa Parish suffering these days."

"But I want to learn how to play guitar and sing like Huddie Ledbetter," the boy shot back.

"Leadbelly singin' about Angola and shootin' and stabbin'. You need to be thinkin' 'bout goin' to school and makin' something of yourself and gettin' outta these fields and off this comp'ny land."

"But you promised! You told me you would."

"I said I'd think 'bout it, and I'm still thinkin'." With that, the old man cranked the tractor once again and inched off to another section of the field.

Butch was shaken. He wanted to learn to play and sing the blues like Huddie Ledbetter. And Immanuel had promised him. But even if Immanuel wouldn't teach him, he was determined to learn, because as early as twelve, Butch was a believer in the blues.

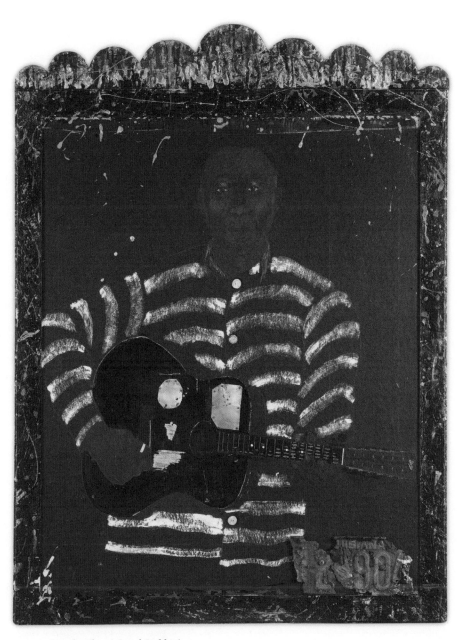

Angola, Shootin' and Stabbin'

2

My Little Artist

Every time I see the sky, I think of you, my little artist
How you love your blues and greens.
And sometimes too, I realize that what we have transcends this life,
And I know, just what it is . . .

It's a beautiful thing between a woman and a man,
You can't live without it . . .
A beautiful thing between a woman and a man,
That you can't live with . . .

"HEY, RODNEY, GIMME TWO FINGERS of vodka in a number-three wash-tub!" Butch shouted. He drained the shot glass of a double Jack Daniels. The smell and the heat lit up his senses. The pepper of it flowed all the way down his throat. He loved the taste of it, the smell of it. He loved being drunk. He wrapped his Miller High Life chaser in a blue bandana and chugged about half of it. "Goddammit, I love this shit," he said to no one as the Jack pinged his heart and went straight to his head. "It makes me a fuckin' poet."

"I'm just bullshittin', Rodney—give me another double Jack and a Miller."

The bartender, accustomed to Butch's rants, hadn't heard the first order anyway. Butch fumbled in his pockets for change and angled for the pay phone in the corner by the door, carrying his Miller High Life wrapped in the blue bandana. "I gotta call Sophie," he thought. Sophie Fischer was the current object of his frenzied affection. She had everything he was looking for in a woman at that moment. She was twenty, like him, with hair

4

as black as Shinola shoe polish and skin as white as a sailor suit. He never could remember the color of her eyes, but he knew they weren't blue—they were some exotic Jewish color. He loved having a Jewish girlfriend—it made him feel artistic. He laughed to himself when he thought that his hero, Governor Earl K. Long, would call his girlfriend "a Jewess."

"Hello," Sophie said into the phone.

"Hey, baby, how you doin'?"

"Butch, I've been worried about you. Why didn't you call me this morning?"

"Shit, I been here, where you been? And I'm calling right now," was his slightly belligerent response.

"Are you drunk?" Sophie asked.

"It's Tuesday, ain't it?"

"Oh, Butch, why are you drinking in the middle of the day on a weekday?"

"'Cause it's Tuesday, goddammit, and you know I get drunk every Tuesday."

Sophie was all heart and soul, empathy and connection. She volunteered at the Negro children's home, she worked for McCarthy, and she believed she could make a difference. It was a self-imposed requirement that she make a difference.

She had never wanted to be attracted to Butch, but his physical appeal was overwhelming—all that shiny black hair and that easy, toothy smile. Sophie hoped that, with her love and guidance, Butch would evolve into a physician like her dad or a lawyer like her uncle, and that he would be a good, stable father and husband. He would become all the things she wanted her man to be. But at the bottom of her ample soul and heart, she knew that would never happen. Butch would never be anything but what he was—a fragile, complicated, creative, binge-drinking child. Sophie said, "I love you Butch," and hung up.

"Bitch," Butch said. "She can't hang up on me, I love her."

"Rodney, gimme two fingers of vodka in a number-three washtub. The bitch hung up on me."

★ ★ ★

"Honey, are you sure you don't want to come with us?" Dr. Fischer asked. "We're just going for something simple."

"Thanks, Daddy, but I don't think so," Sophie replied. "I'll just stay here and read or paint. I'm working on a painting of the Gulf for Butch."

Sophie thought about her dad as she watched her parents drive off to dinner in their Honda Civic. He was so practical and so honorable, such a well-respected doctor in Baton Rouge. His patients lived in mortal fear of him, but their parents loved him. Dr. Fischer hadn't planned to become a pediatrician; it had just turned out that way. He had some inner compulsion to help the helpless, a gene he had transmitted directly to Sophie.

Sophie wandered back to her bedroom, which faced the quiet, shady street. She had three books going—*Origin of Species, All the King's Men,* and a Daphne du Maurier bodice ripper. She reached for the du Maurier; somehow it suited her pensive mood.

A rustle in the hedge near her street-side window made her jump. She looked up to see Butch at the window. He was pressing his palms flat against the window frame and staring into Sophie's room, wild-eyed and drunk.

"Butch, you scared me!" she blurted. "God, you scared me."

"You hung up on me," he said. "You can't hang up on me, I love you."

"Well, you promised that you wouldn't drink during the week, and look at you. You broke your promise."

"Technically, this isn't drinking during the week," Butch responded. "I started Friday so technically this is still from the weekend. Anyway, come on outside."

"I don't think that's a good idea," Sophie said. "I told you I wouldn't be with you when you were drinking."

Butch slammed his palms against the window frame. "Come outside, goddammit! I need to tell you something."

"OK," she said, "but I meant what I said. I'm not going out anywhere with you."

"Fuck it, Sophie," Butch grumbled. "Just come out here for a minute."

Sophie reluctantly made her way to the front door. She and Butch had danced this dance before, and she knew what to expect—there'd be a tirade, some crying, another tirade, maybe more crying, with a little self-pity

6

thrown in for good measure and then an embrace, a kiss, overpowering physical passion, then repeat the process all over again at some other location.

She opened the front door. Butch was on the other side of the screen, weaving like the bugs circling the light on the front porch.

"Are you OK, honey?" she asked.

"I'm fine. I just love you, and you can't hang up on me 'cause I love you. Come on out here for a minute."

Sophie hesitated. She was safe behind the screen door. He was drunk and mad, but she knew he wouldn't make an aggressive first move.

"Why don't you just go home and go to sleep and we'll talk about it in the morning?"

"OK, I will, but just come out for a minute," Butch said with familiar contrition.

She hesitated again, but eventually she reached down for the screen-door latch. "I'm just going to come out for a second to give you a hug and a good-night kiss" she said, "and then I want you to go and get a good night's sleep."

She stepped out onto the small front porch. Butch wrapped his arms around her, pinning her arms to her sides. He was ironworker strong. She felt the hard history of construction labor in the muscles in his arms.

"Butch, you said we were just going to talk."

"We are just going to talk, baby, but I just want to talk at my place. Come with me."

"I don't want to, and I want you to let me go. Stop this, please."

"No, Soph, I want you to come with me." Butch tightened his grip around her arms, lifted her up, and started walking toward his red El Camino in the driveway.

"Don't do this, Butch," she said. "You told me you just wanted to talk."

"I do, baby, but I can't talk here." He opened the passenger door of the sawed-off pickup truck and slid an unresisting Sophie into the passenger seat. He took the passenger seat belt and extended it to its full length, reached over Sophie and got the driver's side seat belt, made a loopy knot out of both, and poked the dangling end into the passenger-seat buckle.

Sophie was resigned. She didn't resist, and she wasn't afraid. She knew that submission was what it would take for him to let go, physically and

emotionally. He loved to fight, and she didn't. "I'll go with you, Butch, but don't make me feel like a prisoner."

"I just want to make sure you come with me, Soph, 'cause we've got to talk."

Butch walked around to the driver's door, swung it open, and got behind the steering wheel.

"We're going home, baby," he said and cranked the pickup's engine. Six blocks away Butch had rented a small apartment, and they skidded into the gravel driveway, almost crashing into the faux wrought-iron carport supports. Butch threw open his door and stumbled around to Sophie's side, fumbling with his makeshift restraint until he got her unbuckled.

"Are you done?" she asked. "Can I go home now?"

"No, baby, come in with me. We're gonna talk it out. It'll be all right, I promise." His slurring had gotten worse. The fatigue, the tension, the Jack Daniels, the beer, the gin, the whole afternoon of self-pity and resentment was building a cumulative weight. Wearily, Sophie slid out of the truck and walked with Butch to his apartment. Hearing him out right now would be better than crossing him.

The door opened into a small kitchen that led into a sparsely furnished living room with a sofa and a television set on a stack of empty Coke cases. A poster of B. B. King, five copies of the 45-rpm record of Arthur Conley's "Sweet Soul Music" arranged in a circle, and a graffiti scrawl of the words "Andrew Loog Oldham Producer of the Rolling Stones" comprised the principal graphic art in the living room. Sophie sat down on the edge of the couch.

"Honey, you know I love you," he said. "You know I can't live without you." He began to pace back and forth in front of Sophie. "Why did you hang up on me?"

"I can't be with you when you drink," she said. "I love you too, but it just doesn't work when you're drinking."

"Shit, I drink all the time. If you can't be with me when I drink, you can't be with me at all. Is that what you're sayin'?"

"As much as I hate to admit it to myself, Butch, I'm afraid it is."

"Does this mean you're breaking up with me? 'Cause you can't break up with me. Goddammit, I'll break up with you before you break up with me."

"Well, however you want to handle it, honey," she said, with the compassion, maturity, and wisdom that Butch simultaneously loved and hated. "I just want what's best for you, and I don't think we can agree on what that is."

"Fuck you, Sophie!" Butch shouted. "You're an arrogant, holier-than-thou bitch! Just fuck you and your doctor daddy and your MBA or whatever the fuck degree it is you're getting. Fuck you and walk home."

"I love you, Butch," Sophie said, "and I want you to have a full and wonderful life but . . ."

Butch cut her off. "Fuck you! Walk home." He stormed back into the kitchen, tore open the fridge door, and pulled out a Miller High Life. He wrapped a blue bandana around it, scrounged around the nearly empty pantry for what was left of a half pint of Jack Daniels, and slumped down onto the couch and turned on the television. Johnny Carson was on, and Butch turned the volume up so loud that the little speakers distorted the sound. Sophie walked over to him, bent down, and tried to kiss him on the cheek. He pushed her away. "Fuck you. Walk home."

"Good night, honey," Sophie said. "I want only the best for you." She turned toward the kitchen door.

"Fuck you," Butch said. "Walk home."

He turned the television volume even louder. As Sophie walked out of the living room, through the kitchen, and out the back door, she looked straight ahead, half-expecting him to throw something at her. Instead, she heard the sound of breaking glass as his empty bottle of Miller High Life hit the wall.

Butch half-smiled at what would come next as he jumped into the dark, comfortable, seductive hole of his depression and self-pity. "I love this shit," he thought. "It makes me a fuckin' poet."

3

L.A., Oh No!

Oh Johnny, go get the money,
Bonnie don't you love your Dove
Are y'all ready yet, did you load the jet?
You know what I've been thinking of . . .
Tangier, Monterey or Durango . . .
Cherbourg, Stockholm or Tupelo . . .
3-C-295 awright, but L.A., Oh no!"

CAROL STORMED OUT OF BUTTERBEAN'S CAFÉ and turned left, walking
purposefully up the slight rise of Chimes Street toward Highland Road.
Her boyfriend and future husband struggled to catch up.

"Man, I hate that place," she said. "It's the same thing every time with
that grouchy old bigot. I'm never going back. I don't know why we go there
in the first place."

"We go there because it's got the best burgers in town, and you love to
eat, that's why," he said.

"Yes, but he talks so ugly about colored people and says terrible things
about President Kennedy. I just hate it. And that poor sweet lady Eola who
works for him—I don't know how she puts up with it."

"Well, there's probably some history there, you know. You work that
long for somebody, you probably end up puttin' out."

Carol stopped and turned to face him. "Stan, I hate it when you reduce
everything to sex, money, or food. That's your explanation for everything
that people do."

"It is what it is," he replied and kept walking.

They passed the bookstores, pool halls, head shops, and cafés all dis-

playing purple and gold or Greek letter sorority and fraternity bric-a-brac on their way up to Highland Road. Highland Road split the LSU campus in half and was about a mile east of the Mississippi River. It got its name because it sat on the edge of a ridge of the last high ground before the river. Until the levees were built, the Mississippi would overtop its natural banks in the spring thaw and spread millions of yards of rich, black alluvial soil onto this floodplain. It was the richest, blackest, most fertile topsoil in the world, runoff carried downstream from the midsection of the whole North American continent. It was deposited from the riverbank to Highland Road on the east side and from the riverbank to the Atchafalaya basin on the west side. There was no ridge of high ground to the west, just more rivers and more drainage. So the soil on the east side of the river between Highland Road and the Mississippi's natural banks was perfect for growing vegetables, especially Creole tomatoes.

Years later, when Carol and Butch were together, she would scour Highland Road for the part-time tomato growers who sold their excess production of Creoles. She had two favorites she dubbed "Mr. Taste" and "Mr. Neat." Mr. Taste's tomatoes, though sometimes misshapen, were sublime. His garden was disorganized, with sucker-filled plants randomly scattered about. Mr. Neat's tomatoes, equally delicious, came from the most orderly, straight-row garden she had ever seen. Each plant was meticulously tended, totally sucker-free, and tied to perfectly vertical poles of exactly the same height. She never saw either man. They could have been women. There was a scale and an honor box at each garden so you could pick out the tomatoes you wanted, weigh them, and leave the payment in a box. Carol would pick out the best to make Butch a messy, delicious Creole tomato sandwich. It was simple to fix—white bread, mustard and mayo, a little salt and pepper, and the tart juice from a freshly cut Creole tomato—and, along with a cold glass of milk, it was one of Butch's favorite meals.

"Look, there's my boy Swan," Stan said. "That crazy son of a bitch is going to Hollywood."

Carol looked over to see a dark-haired young man in white painter's overalls with no shirt swinging around the street sign at the corner of Chimes and Highland. He got almost horizontal as if he were on some

makeshift gymnastics apparatus. Run a few steps and elevate, run a few steps and elevate . . . around and around. Carol wondered how he didn't get dizzy and throw up.

They approached him but couldn't get closer than the six feet or so he needed to make his circular swing.

"Swan, what you doing there, man?" Stan asked.

"I'm going out for the gymnastics team," he laughed. "They got some great-looking chicks in gym, and I want to meet 'em."

"Man, I thought you were going to Hollywood to be an actor."

"I am."

"When?"

"After gymnastics."

"Man, you're crazy. Are you drunk or trippin' on acid?"

"A little of both, maybe, but not enough to interfere with my practice."

He continued to swing around the signpost. Same speed, same procedure. Run a few steps, elevate. Run a few steps, elevate.

"Butch, I want you to meet my girl, Carol. We might get married."

"You called him Swan," Carol said.

"I know. Butch, Swan, Led—he's got a lot of names."

"Hello, Slim," Butch said, instantly giving her an endearing nickname. "Stan's a lucky guy, 'cause you sure are pretty. Are you on the gymnastics team?" He continued to swing.

"No, and doesn't that make you dizzy?" she asked.

"Not really. I like it."

"Well, I get dizzy just looking at you."

"I'm flattered," Butch said.

"That's not how I meant it," Carol said. "I meant it makes me dizzy to watch that stupid thing you're doing on the sign pole."

"Groovy," Butch wheezed, getting short of breath.

"Let's go, Stan," Carol said. "This guy's crazy." She turned to walk away.

"Good luck, Swan," Stan said, "and don't forget me when you're a big star."

"That's me baby, a big star . . . just like Marlon Brando."

"That guy's crazy," Carol said. She turned her head back over her shoulder for one last look. He was still doing it. "That guy's really crazy."

Carol fought the thought that the crazy guy doing improvised gymnastics on the signpost was the best-looking man she'd ever seen.

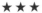

Butch was sleeping, and Johnny was getting tired of driving. The stretch of U.S. 290 from Fort Worth to El Paso—600-plus miles of little towns, farmland, and endless ribbons of blacktop—was brutally boring, especially for the driver. Johnny's yellow Chevy van was loping along. They'd packed it front heavy so it felt like they were always going downhill. It was a '65 and nearly five years old. Johnny's dad had helped him get a good deal on it. The fact that it was taxicab yellow and that Butch had brightened it up with a huge flower-power graphic made it a real head-turner. It was a plus that the huge back cargo area could accommodate most band equipment— drums, amps, guitars, even P.A. sets if they weren't too big.

A mileage marker reading *El Paso 88* caught Johnny's attention. "It's 4:20," he thought, "and no sign of sunlight. We shoulda' been closer by now." He thought about waking Butch but decided to let him sleep because after El Paso, Butch would be driving.

Johnny knew that if he wanted to be in the music business in 1969, he'd have to be in Los Angeles. He had a job waiting for him at Studio Instrument Rentals. It was grunt work, getting equipment and instruments from studio to studio, but it was a place to start. Johnny had saved some money for the trip. Butch didn't have anything lined up and didn't have any money, but he could find jobs. He could do anything. Carpentry, ironwork, manual labor, shipbuilding—name it and he could do it. Johnny also knew that Butch probably wouldn't do anything but try to act or play music or write songs or hang around the pad all day, goofin' off and drinking. "Being creative," Butch called it. Johnny called it "goofin' off" and tolerated it most of the time. Butch had some inner alarm that went off when he knew he'd been mooching too long. When that alarm sounded, he'd go out and find some source of money and buy everything for everybody until the money ran out.

Bonnie Mayer had gotten Johnny his job. Some uncle of hers knew Doris Day's son, who owned the instrument-rental company or some kind

of screwy L.A. connect-the-dots deal that always ended up back at a celebrity or movie star or record-company president. He met her when she was fronting an antiwar folk tour of the South that was not very well received. Being "antiwar" in the South in the sixties wasn't going to win you many friends. It was anti-American, pothead, and Bolshevik to be antiwar. Bonnie played a coffeehouse in Baton Rouge to an audience of five hippies and Johnny. He thought she was cute, and he introduced himself as a road manager. Bonnie believed him, and she told him that if he wanted to be in the record business he'd have to move to Los Angeles. He would make that move. He just hadn't figured on dragging Butch along. Having Butch along was always a wild card. It could be funny and exciting, but it could also be a pain in the ass.

The following sun finally started to push some light through the back windows of the van. Butch began to stir. "Where we at, John Raymond?" he asked. "Are we there yet? Is this L.A.? Let's go to Juarez and get some pussy and some huevos rancheros. I need some boots. Let's go to the boot store."

"The boot store's not open yet, Butch. It's only quarter to six," Johnny replied, laughing at Butch's stream-of-consciousness wake-up outburst.

"You sleep good, hoss?" Johnny asked. "'Cause you been at it since we left Fort Worth, leaving my dumb ass to chauffeur you all over Texas."

Butch sang back, "No, I ain't no cowboy, but I often have been throwed. I ain't no chauffeur, but I can hold it in the road," part of the refrain from an unfinished song of his. "So let's go to Juarez and get some huevos rancheros. Must have huevos, must have huevos, must have huevos," Butch chanted.

"We're going, "Johnny replied, "and after we eat the damn huevos, you're driving and I'm gonna sleep a while."

"Fine, John Raymond. And don't worry 'bout a thing. I'm just gonna have a little tequila chaser with my huevos and I'll be a drivin' fool."

Johnny shot back immediately, "Bullshit, Butch, no tequila this morning. You gotta help drive. I'm about to crash."

Johnny snaked the yellow van south of El Paso toward the Mexican border. The border crossing would be easy at six in the morning. The border-

control people were all tired too. Johnny pulled into the shortest line at the crossing and inched his way to the gate.

"What is your purpose in visiting Mexico?" the uniformed Federales in the booth asked.

"Going to get some huevos rancheros and some pussy," Butch blurted out, jumping up in his seat.

"He's just kidding, officer," Johnny countered as quickly as he could. "We're just going over for breakfast, and then we're gonna keep driving to California."

"Pass," the officer said.

As they drove into Juarez in search of a likely-looking breakfast joint, Johnny fumed.

"Why do you do shit like that? Suppose the guy had gotten pissed and made us go inside or something? We could have been held up for hours."

"Aw, man, he knew I was just kiddin'. I almost told him we were going to pick up a bale of marijuana. Then we'd 'a really been up against it."

Johnny shook his head, partly in resignation, partly in anger. "Man, the shit I put up with."

Butch dismissed it with a laugh. "Aw, cool it, John Raymond. I'm just gettin' some grins."

4

Rock Bottom on Romaine (St.)

If you see me comin'
Baby, please be sweet,
I'm in a dangerous mood,
Don't you mess with me . . .
Lord, I wrecked my car; I'm drunk on gin,
I'm so damned scatterbrained
I'm sky-high in Hollywood and rock bottom on Romaine.

LOS ANGELES IN 1969 WAS HEAVEN ON EARTH for a twenty-one-year-old. There were so many revolutions it was hard to keep track. There was the antiwar revolution, the sexual revolution, the drug revolution, the music revolution—and the civil rights revolution energizing them all. Butch almost pissed his pants every day that he woke up in it. He went to a Black Panther Party meeting in Inglewood with Johnny, and they both almost got an ass-whipping when Butch asked if the Panthers agreed with him that Jefferson Davis was a great American hero. He went to pot parties in the Hollywood Hills with Duke and William and got so stoned he forgot his name. He went to sex parties in Laurel Canyon with beautiful women from all over the world, They thought he was cute and sexy, and they loved to kiss and hug and screw. "It's free love, baby," Butch would say. "It's free and I love it!"

And Los Angeles in 1969 marked the first time that trends were moving from the bottom up. Young people weren't imitating their parents; their parents were imitating them. In Amite, Louisiana, there hadn't been much more to do than picking strawberries, logging, or doing ironwork

on commercial construction projects in New Orleans or Baton Rouge. In L.A., Butch forgot all about strawberries, logging, and ironwork. He even blocked out all that complicated family shit that happens in small towns all over America. Butch knew about that. He described his relationship with his father as "thorny as a blackberry bush." Every day in L.A. brought a brand-new challenge and a brand-new thrill. Johnny had already been promoted from grunt to boss at Studio Instrument Rentals, and he was scheduling other grunts around town. He and Bonnie were making the rounds of producers and publishers, trying to get Bonnie a deal, and a couple of times they'd almost gotten the green light on a demo budget. Butch was writing songs and getting drunk and getting laid and going to the Actor's Studio on Sunset to study with Susan Strasberg and her dad. Johnny would pick him up after class, and he would be so animated and full of energy and inspiration that he would recite lines from his favorite movies for an hour or so until he wound down.

"You wanna hear my philosophy on life? Pffftt . . . do it to him before he does it to you."

"Who do you think you are, a pair a' queens? Just remember what Huey Long said, that every man's a king and I'm the king around here . . . and don't you forget it."

All Marlon Brando, all the time.

Number 6037 ¼ Romaine Street was a great place to live. It was little more than an alley just off Gower Street, and Butch had put up a crude hand-drawn sign that read, "We Fix Flats, 2$." Every other night or so, he and Johnny would walk down to Lucy's El Adobe for dinner. Sometimes Bonnie came with them and sometimes Duke or William came along. Duke and William were two more Louisianans who'd been pulled to L.A. The place had its own magnetic field. And, like everyone else who came to L.A. in the sixties, they wanted to be in the entertainment business. The ones with a political agenda headed to San Francisco; L.A. was all show business. Duke wrote and sang and produced and had a huge deal with the producer Lou Adler that had gone sour because everybody in the band took the production budget and bought sports cars and dope and duck camps

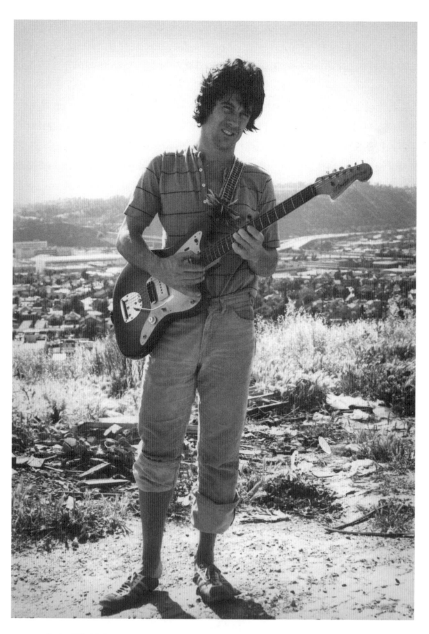

L.A., Oh No!

back home. William was a set decorator, an improbable choice of professions for someone so cerebral, outdoorsy, and manly. He mostly worked when all the artier types were busy.

There was also a large population of New Orleans musicians in L.A. then, held together by the presence of Harold Battiste. Earl Palmer and Lee Allen had left New Orleans a few years earlier and were the main session players on the R&B records cut in L.A., especially the Larry Williams and Little Richard hits for Art Rupe's Specialty Records in Venice and for the Bihari brothers' Modern Records. But Harold worked the bigger crossover acts and produced monster hits for Sonny and Cher, and he and Mac Rebennack created the Dr. John character, who also had a string of hits, so there was reason for Butch and Johnny to be optimistic about getting a record deal. The New Orleans influence on the L.A. music scene gave them an entrée.

"Are we going to Lucy's tonight, John Raymond?" Butch asked.

"Well, I'm not cooking and you can't cook and we have to eat something somewhere," Johnny said, "so I guess we're going to Lucy's, and I guess I'm going to pay for it."

"Man, don't get all bitchy on me," Butch replied. "I'll go down to Marina del Rey tomorrow and work on the boat and get some money and I'll pay for shit for a while." The owner of Studio Instrument Rentals had a big wooden-hull Chris-Craft in dry dock in Marina del Rey, and he would pay Butch a hundred dollars a day to sand and polish and paint it. When Butch worked on the boat, he lived on it too, and he could be gone for weeks at a time.

"Y'all do any good today?" he asked.

"Yeah, we had a meeting with a producer named Artie Wenrik, and Bonnie sang some of her tunes. She sang her ass off, and he just sat there. She pulled up a chair in front of his desk and sang her heart out. I couldn't tell whether he liked it or was just being nice, but these sons a' bitches don't get paid to be nice, so I guess he liked it."

"Man, that would be fine if she could get a deal," Butch replied.

"Yeah, she really wants it, 'cause she thinks if Linda Ronstadt can get a deal and cut hits, she can too."

"She can, man, "Butch said. "She damn sure can, goddammit." He said it with a crazed conviction that turned him inward and hostile. "She damn sure can, goddammit. If Linda fuckin' Ronstadt can get a deal and cut hits, then Bonnie damn sure can. And if she doesn't, there's something wrong with the goddamn system, John Raymond."

Butch had an anger toggle switch, and Johnny had just tripped it. The switch turned him from caring, loving, empathetic, and funny to raving, pacing, and lunatic—ranting about minorities, villains, real or perceived enemies, real or perceived affronts, anything just slightly disrespectful or different from him. That was the bad part. The good part was that the switch didn't stay flipped for long. Some inner circuitry tripped it back to the off position before he got totally out of control. Somewhere in that whole tangle of snakes in Butch's head was a decent, caring soul.

"Yeah, well some people cut hits and some don't," Johnny replied, trying to calm Butch down. "Anyway, don't get all torqued up about it 'cause it'll either happen or it won't."

"I know, but it's you-know-who running this business, and if you're not a Jew, it's hard to get a deal," Butch fumed.

"Let it go, hoss . . . this ain't about Jews or anything but cutting hit records," Johnny replied. "If you get hung up on the reasons why you don't do something, then you never do anything."

"Well, anyway, she should get a fuckin' deal, and if she doesn't, it's the fuckin' Jews' fault, Heil Hitler," Butch said, now laughing and making an exaggerated Nazi salute. That was Butch's MO—anything to get a reaction.

"Do me a favor, Butch," Johnny said. "Don't let Mr. Strasberg or Susan know about your sick fascination with Hitler, OK?"

"Aw, man, I just say that shit for grins. You know that, Johnny Rogers," Butch said, quoting and imitating Earl Long and feigning a series of quick jabs to Johnny's midsection.

Butch loved sanding the big Chris-Craft and polishing its brightwork. The wooden hull felt solid and substantial under his hands. He and Ferd

had been on it when Ferd had it towed down to Marina del Rey from San Francisco, and it had a great feel on the water—even under tow. It rolled through big Pacific swells hardly getting off keel, staying as level as the tug pulling it. Butch and Ferd had a pleasant, chore-free voyage. It would have been a lot of work if it had had a functioning engine, but that's why the guy sold it to Ferd so cheap—the engine needed to be completely re-built. Butch didn't work on engines, but he'd sand and polish the boat anytime. Ferd's dad had invented some massive consumer product like meat tenderizer or Neosporin or maybe both, so he had lots of money, and he paid Butch well for working on the boat. He paid him a lot more for working on the boat than he paid him for working at Studio Instrument Rentals, which, ostensibly, was Ferd's business. On this Saturday morning, Butch was waiting for Ferd at the gated entrance to the marina. It was nine thirty, and Ferd was supposed to be there at nine. Butch was getting a little impatient and started to pace back and forth across the length of the marina, silently checking off which of the hulls were wood and which were fiberglass. The fiberglass outnumbered the wood by a large and increasing margin. He walked into the marina office and asked to use the phone. "Sure," the marina radio operator said without looking up, "no long-distance."

Butch dialed Romaine Street. Johnny was still sleeping so the phone rang for almost a minute.

"What . . . what time is it?" Johnny slurred into the phone.

"John Raymond, it's me," Butch replied, "and it's about ten o'clock, and I'm waiting for Ferd to meet me at the marina. It's payday, baby. Let's have a party."

"Party?" Johnny mumbled, "I didn't get in 'til four, and I'm going back to sleep as soon as I hang up on your crazy ass."

"Well, don't hang up, and when you do get up, get Bonnie and Duke and William and let's all meet at Lucy's at about seven thirty tonight. My treat. 'It's Saturday night and I just got paid, fool about my money don't try to save . . . woooh.'" Butch sang the lyric from "Rip It Up" in his best Little Richard imitation.

"All right," Johnny said, "but let me go back to sleep now, OK?"

"Si, Juan Ramon," Butch replied in cracked Spanish, "veale esta noche, hombre . . . seven thirty, Lucia's El Adobe, mañana, adios, kemo sabe."

Ferd's Corvette pulled into the marina just as Butch was hanging up. Butch ran out to stop him before he passed the marina office.

"Hey, I'm right here!" Butch yelled at the Corvette. It stopped, stirring up a little gravel and oyster-shell dust under the wheels. Butch walked around to the driver's side, where Ferd was slouched down under the wheel. "Nice day," Butch said. "Typical L.A. July day: 74 and sunny, no chance of rain."

"Yeah, I guess," Ferd replied. "I'm used to it, though. I wish it would rain sometimes."

"Forget rain." Butch answered. "I've had enough rain for both of our lifetimes. Sometimes it rains so hard in Louisiana that you feel like you're living underwater. I'm done with rain."

"Well, I've got your money, so you can be done with whatever you want to be done with, Butch. Just don't blow it all today." Ferd counted out $1,300 in twenty-dollar bills. "A hundred bucks a day for thirteen days. See you at the store on Monday?" he asked.

"Yessir, I'll be there," Butch replied, recounting the money and not looking up at Ferd. "You can trust me, old son, I'll be there."

"Well, we've got a busy week next week, and we need all hands on deck, if you'll excuse the maritime pun in a boatyard," Ferd said. "No benders now, Butch. I'm counting on you."

"You can trust me, old son," Butch said.

"I hope so," Ferd replied as he put the Corvette in gear and slowly drove off to check out Butch's handiwork on the boat.

Butch went back into the marina office. "Can I use the phone again, hoss?"

"Sure, no long-distance."

Butch fumbled in his jeans pocket for the card with the South Coast cab number. He dialed it. "I need a taxi to the Evinrude marina in Marina del Rey," he said.

"You need to go there or get picked up there?"

"Picked up. You know where it is?"

"Yep. I'll have somebody there in ten minutes or less."

Butch hung up and walked toward the office door. "See you later, hoss," Butch said and gave a halfhearted wave.

"Sure" said the man hunched over the radio, "no long-distance."

5

I Ain't No Chauffeur
(But I Can Hold It in the Road)

Some of you know me little,
Some of you know me well,
I just got in from Texas,
I been out on the trail.
At first in Albuquerque, then ancient El Paso
I became enchanted with old dusty Mexico,
No I ain't no matador, but now and then I have been gored,
I ain't no chauffeur, but I can hold it in the road.

BUTCH WALKED OUT OF THE MARINA OFFICE letting the screen door
flap closed behind him. He walked through the marina gate and onto the
street to wait for the cab. There was a small bait and provision store across
the street from the marina, and Butch was hungry. He did an animated
walk across the street, challenging passing cars with an imaginary mata-
dor's cape. "Olé!" he said, feigning a dramatic bullfighting move on a pass-
ing car. He bounded into the bait store laughing.

"Hey, Jose, gimme two fingers of vodka in a number-three washtub,"
Butch said to the Mexican cashier. He responded to Butch with a blank look.

"Never mind, hoss. I'm just bullshittin' you."

Butch scoured the aisles looking for some peanut butter crackers.
He grabbed two packs and started toward the register. He reached into
a cooler for a Coke, wrapped his hand around the can, and then let it go,
grabbing a six-pack of Miller High Life instead. "Hell," he thought, "I'm
thirsty and I got a long ride ahead."

A black and white Chevy Impala with a Sun Coast taxi logo turned into

the marina gate. "Hey, I'm over here!" Butch yelled at the cab and ran back across the street. He jumped into the backseat on the driver's side and said, "You came for me, right? Evinrude marina?"

"Yep, you it. Where to?" the driver asked.

In the backseat of the big Impala, Butch felt like he was a mile away from the driver. "Man, this is a big-ass car," he said. "Can I come sit up front?"

"Your choice, but where we going?"

"Well, this is a special mission," Butch said as he slid across the backseat to the passenger's-side rear door and opened it. "Hold on a second and I'll tell you." He hopped into the front seat and looked down at his watch.

"How long will it take you to get to Fresno?" he asked.

"Fresno?" the driver blurted out. "Did you say fuckin' Fresno?"

"Yep, I need to get to Fresno and back by seven thirty tonight. Can you handle it?"

"Oh, I can handle the motherfucker all right, but I gotta check with the office and see if I can even do it, much less do it in the time you need it done."

"Well motherfuckin' check with the motherfuckers and see if we can get this motherfucker done," Butch answered. "My motherfuckin' ass needs to get to motherfuckin' Fresno, and the motherfucker needs to get there today!"

"I'll ask," the driver said and reached for his radio mike.

"Charlie: 3737 here. I need to ask you something, over."

"3737 this is Charlie; you got the marina fare?" came the squawk back over the blown-out radio speaker.

"Yeah, I got him, and he wants to know if I can take him to Fresno. Can I?"

"Fresno?" squawked the voice in the speaker. "He wants you to take him to Fresno?"

"Roger that. Can I do it, and do I let the meter run or what?"

Charlie squawked back, "Hold on, let me check with the boss. I think you can, but hold on."

The driver turned to Butch, who was now eating his first pack of peanut butter crackers and drinking a beer. "Man, can't you find a cheaper way to get to Fresno?"

"I could, I guess," Butch answered, "but I'm in a hurry and this looks like as good a way as any. What kinda car is this anyway? The sumbitch is big enough, ain't it?"

Butch's question was interrupted by the radio.

"3737, you there? Over."

"Roger, what's the deal? Over."

"Boss says you can take him, but it's $750 plus gas, and get it up front if he wants to go."

"Roger that, I'll let you know." He turned to Butch. "You heard him—$750 up front plus gas and a hundred-dollar tip for me."

"Shit, baby, let's roll," Butch said, reaching into his pocket and counting out $760 in twenties. "You get the tip when we get back. You wanna beer?"

"I think I will," he said. "You wanna smoke a joint? I'm Tim—what's your name?"

"I'm Butch, aka Charles E. Hornsby, Led Smutch, Butchy-Boy Floyd, Big Fat Butch, and my personal favorite, the Swan."

"That's a lotta names, man. I'll just call you Butch, if that's OK, and you just call me Tim."

"Damn, yeah, Tim. Let's get this big motherfucker in the wind. I need to get my ass to motherfuckin' Fresno. Where's the reefer?"

Tim was a big guy, 230, 240 pounds, with a long braided ponytail. He was dressed in the full hippie uniform—bell-bottom jeans, floral shirt open to the waist, pukka shell necklace. He had a huge reddish beard that he constantly stroked while pontificating on just about any subject. Butch was interested in his opinions for the first hour or so, about to Bakersfield. By then they had smoked two joints, made two stops for beers and bathrooms, and Butch had to make a decision about his buzz.

"Man, Tim, how you drive on this shit?" he asked. "I either need to take a nap or get some whiskey."

"S'easy man," Tim drawled. "You just kick back and get one with the road."

"One with the road, my ass. I'm seeing spiders and school buses and fuckin' dinosaurs crossing the goddamn highway. Shit. And now I'm hungry again and I ate all my peanut butter crackers. Let's stop in Quail or Tipton or someplace and get something to eat. I'm fuckin' hungry.

Butch leaned against the passenger-side door. He put his head on the window. The glass magnified the sunshine and made the top of his head hot. His thick black hair retained the heat, and he felt like his brain was boiling. He had a soft beer high going, and he was stoned from the reefer. He closed his eyes, and in less than a minute he was exhaling little puffs of air, "puh, puh, puh," and fast asleep.

"We're here, man," Tim said. "We just crossed East American Avenue. You got an address where we goin?"

"Uh, shit, I fell dead-ass asleep," Butch said. "Where are we?"

"Just crossed East American Avenue in Fresno. You got an address?"

"No, but I can find it. We're looking for a pawnshop on Tulare Street. Myers, I think. Can you ask somebody?" Butch yawned and rubbed his eyes and hair. "Man, how can you smoke that shit and not fall asleep?"

"I did sleep, man," Tim said. "I slept from Tipton to here."

They found the pawnshop on Tulare Street, Myers Pawnshop. It was clean and well lit . . . for a pawnshop. Butch pushed the front door in and set off a bell chime. An older man with a thin mustache and balding monk hair was wiping down the top of a glass gun case. "Help you fellas?" he asked.

"I'm looking for a Dove acoustic six-string that y'all bought from a hippie chick about three months ago. She had long, straight blond hair, about five foot six, green eyes and pretty. Remember her?"

"I do," he responded. "I remember her. She had a frat gig at Fresno State and they stiffed her on the money 'cause she played folk tunes. She had to sell her guitar to get back to L.A."

"That's her. Is the Dove still here?"

"Right over there," he said, and pointed to the sunburst orange and yellow body of Bonnie's Dove hung up on a fiberboard punch wall with about a hundred other Gibsons, Martins, Fenders, acoustics, electrics, twelve-strings, mandolins, banjos, each with its own sad reason for being there.

"You want it?" he asked.

"Yeah, I do. How much?"

"Three hundred."

"Three hundred? Y'all only gave her $150 for it. How can you sell it back to her for $300?"

The man gave Butch a bemused but slightly irritated look.

"In the first place, I'm not selling it back to her; I'm selling it to you. In the second place, there's overhead and profit I've got to cover; I do this to make money, not friends. And in the third place, there's inflation to take into account—so if you want it, it's three hundred bucks. And I don't need a hard-luck story. Every goddamn one of those guitars has a hard-luck story. That one comes with or without the hard-luck story at three hundred dollars."

"Fuckin' rip-off," Butch mumbled.

"I heard you. Get out. I'm not gonna sell it to you."

"Nah, man, it's not a rip-off," Butch said quickly, offering some well-rehearsed and slightly panicked contrition. "I understand you gotta make a living. Here's the money." He counted out three hundred dollars.

Mr. Myers took an old-fashioned grocery store reach-handle and squeezed the neck of the Dove. He lowered it directly into Butch's hands. Butch passed his hand over the beautiful sunburst effect on the front of the guitar body and held it up close to examine the fretboard. He brought it to the playing position and made a G chord. "It's out of tune," he said to Mr. Myers. "Don't you tune 'em before you sell 'em back at twice what you paid for 'em?"

"You want your money back, smart ass? . . . 'Cause it don't mean shit to me whether you buy it or not."

"Let's go, Tim," Butch said and walked angrily toward the door. "Let's go before I smash this motherfuckin' Dove over that old Jew bastard's head."

"Hey, man, chill out," Tim replied, opening the front door of the pawn shop to let Butch out. "I'm Jewish, too, man. And besides, I think your boy is Irish. There's a shamrock on his sign."

"Aw, I'm just bullshittin'. I wouldn't break Bonnie's Dove."

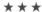

Butch and Tim the taxi driver were stoned, drunk, and half-naked making their way down Melrose Avenue aiming for Lucy's. The big Impala's AC gave out just south of Bakersfield and it was hot as hell, so Tim took off his shirt. In a show of solidarity, Butch took his off too. By Butch's reckoning, the return trip from Fresno was uneventful, but by anyone else's, it was outrageous. Three joints, one beer stop, and, finally, a sweep through a liquor store in Tipton that yielded a fifth of Jack Daniels, a six-pack of Cokes, a quart of orange juice, a pint of vodka, Hershey bars, some Slim Jims, and five bags of assorted chips. Tim and Butch consumed it all, so by the time they were angling down Melrose toward Lucy's, Butch was slaughtering the changes to the Rolling Stones cover of Irma Thomas's "Time Is on My Side" on Bonnie's way-out-of-tune guitar and Tim was singing along.

Lucy's El Adobe was divided into two parallel dining rooms. The main room offered seating for regular folks—customers, Paramount Studios workers, and the occasional tourist. The wall facing the customer dining room was papered over with photos of celebrities and politicians. A small corridor at the back of the main room led to another room of the same size. The big shots gathered in there. Lucy's was a hangout for union organizers, Democratic politicians courting the union vote, migrant-worker advocates, and Jerry Brown. Tonight Jerry Brown and Cesar Chavez were at the same table, discussing the inequities of capitalist society and how to achieve racial and economic justice for the exploited underclass. Back on the regular-customer side, Duke and William shared a booth with Johnny and Bonnie, who held hands under the table. They were a couple but didn't want other people to know it. Everybody knew it anyway, and it was no big deal. They had ordered margaritas and tacos. It was after eight, and Butch was supposed to have met them at seven thirty.

"I knew that sumbitch would pull something like this," Duke said. "He always does this kind of shit. Get everybody gathered to meet him and not show up."

He'll show up," Bonnie said. "You know he's a little scattered, and he got paid today, so there's no telling what his day's been like." Bonnie always came to his defense. Butch did something to women that brought out their maternal side.

"Truth is, though," Duke answered, "we all owe the crazy bastard a great debt."

"What do you mean?" Johnny asked. "I don't owe him anything. If anything, it's the other way around."

"No, I don't mean any kind of money debt or anything, just we all owe him 'cause it's like Cy says, he sucked up all the crazy in the atmosphere and didn't leave any for the rest of us. That's why we're all normal." Duke looked from Bonnie to William and back to Johnny. "There's no crazy left for anyone. He's got it all, God bless him. And he can keep it too." They shared a laugh.

Bonnie said, "I guess. If you think about it like that, we do owe him."

"Y'all know what," William said, "not to change the subject or anything, but whenever we're in here with all these politicians and union guys I'm kinda paranoid about somebody coming in here and shooting up the place . . . and killing a bunch of these cats."

"Goddamn," Johnny said with a half-chewed bit of taco in his mouth, "you are paranoid. You better cut back on the reefer."

The buzz in Lucy's was loud. Waiters were hustling back and forth from the kitchen with margaritas, big plates of rice and beans, tacos, and enchiladas—all the traditional Mexican-American restaurant staples. Part of the heady edge of this place, though, was that everyone knew that on the other side of the wall, politicians and their entourages, fund-raisers and labor leaders were charting a course for social justice in Southern California— and someday for the rest of the country. Maybe.

Tim eased the Impala to the front door of Lucy's on the wrong side of the street, double-parking into oncoming traffic.

"Here you go, Butch, as promised."

"Man, Tim, you're a hell of a driver, I gotta say," Butch slurred his compliment. "How can you get so drunk and not get in a wreck or get pulled over?"

"Cops never stop taxis, man. We get away with more shit driving a cab."

Butch struggled to get his right arm into his shirt while holding Bon-

nie's guitar with his left hand. "Thanks, man, I appreciate it. We did a good thing today," he said and reached to open the door.

"What about my hundred-dollar tip? Tim grabbed his left wrist.

"Oh, yeah," Butch said and dug down into his jeans pocket. He pulled out a crinkled wad of bills. He counted out sixty-eight dollars. "Man, all I got left is about sixty bucks."

"Well, you better shit the rest 'cause you said you'd give me a hundred-dollar tip."

"But all I got is this," Butch said, showing him the wadded bills.

"Well, go get the rest from your friends in there," Tim nodded his head in the direction of Lucy's front door.

"They don't have any money, man, and besides I bought all the refreshments on the ride home, so that makes it about a hundred."

"Yeah, well you also smoked all my joints, and that gets it back down to sixty dollars, so go in there and get the rest from your friends."

"I can't do that, but I'll give you everything I have here, which is sixty dollars and something."

"Fuck it, gimme that and get out," Tim said. "Nothing like a lying son of a bitch to ruin a fuckin' otherwise good day. I ought to kick your ass right here."

"You oughta what?" Butch said in a tone that meant the switch had been toggled. "You oughta what? 'Cause I'll whip your ass right here in front of Lucy's. And you'll be sorry you brought that subject up, hoss." Butch's eyes got a glazed-over and crazed look that caused Tim to rethink his threat. Tim was bigger, stronger, and not as drunk, and he could probably beat Butch, but he had to take those glazed-over eyes and that manic energy into account. "Just give me what you got, man, and get the fuck out of my cab."

Butch took the crinkled wad of bills and threw it at him. He slammed the taxi door as hard as he could. "You made the right choice, son. And you'll live to tell your goddamn grandkids about it."

Tim drove the taxi off into the oncoming traffic. He reached his left hand out the window and flipped Butch the finger.

"And fuck you, too, asshole. I'll whip your ass . . ." Butch shot back to

the departing Impala and walked a few paces after it with the guitar in both hands raised high above his head.

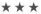

Butch's entrance caused the noisy crowd in Lucy's main dining room to fall silent. It took a few seconds, moving gradually from table to table. He pushed the front door half open and shoved Bonnie's guitar through. He let it hang there at the end of his extended left arm. Eventually, everyone in the dining room, including Duke and Johnny and William and Bonnie, were staring in silence at the sunburst gold and orange Dove six-string. Butch pushed the door all the way in and began to march smartly toward their booth with the Dove in the present-arms position of a military rifle. He sang to accompany his march, "Oh, Johnny, go get the money, Bonnie, don't you love your Dove." By the time he arrived at their booth, they wished they were invisible. Butch made an elaborate presentation of the guitar to Bonnie.

"Sit down, goddammit," Duke said. "Sit down and be quiet or we'll get kicked out for sure." Duke slid out into the aisle and made Butch sit down by William.

"Duke, he got my guitar," Bonnie said. "Butch, how did you find it?"

"Well, honey," he said, "I know how much you love this guitar, and I got paid this morning so I took a taxi to Fresno and got it out of hock."

Duke jumped back into the booth: "You took a taxi to Fresno? Have you lost it? How much did that cost?"

"Well, I got paid today, and I wanted to do something nice for her 'cause she's always doing nice things for us," Butch said, nodding in Bonnie's direction. "So I figured the best thing I could do was to go retrieve a prized possession she'd lost."

Johnny stared straight at Butch. "And you're drunk. You got some money and it made you nuts, and you got drunk and went to Fresno in a taxicab." He shook his head side to side in a slow and weary acknowledgment of another Butch adventure.

"No, I'm not drunk, I'm stoned *and* drunk, and I went to Fresno before I got drunk so you're wrong on two out of three charges."

"But he got my guitar," Bonnie said, blinking back tears. "He thought enough about me to go and get my guitar. Thank you, Butch," she said turning to him. "That was a caring and thoughtful thing you did. Thank you. He got my guitar," she said again to the rest of the booth. "He went and got my guitar."

There was silence for a few minutes in the booth. The rest of the dining room had turned back to their own conversations. Butch was slouched down between Duke and William, pinned in like a ten-year-old made to stand against the blackboard. A slight smile began to form on Butch's mouth. It got wider and wider and eventually turned into a laugh. "Whose ass do I have to kick in here to get some huevos rancheros?" he said. "'Cause I'll do it, y'all know I will."

"Shut up, asshole, and eat this taco," Johnny said, sliding his plate across the table to Butch. "No more scenes."

And there were none until it came time to pay the bill. Everyone had counted on Butch picking up the check, but he had burned up the entire $1,300 that Ferd paid him that morning. They scrambled to pool their cash to cover the check and still came up about thirty dollars short. Bonnie ended up putting it all on her credit card and collected only twenty-five dollars from Duke and William and Johnny, so she paid the largest part. She couldn't afford it either, but she was the only one with a credit card.

"We'll cover that, Bonnie. You shouldn't have to pay for dinner 'cause A-hole here can't manage his money," Johnny said, looking in Butch's direction. "We just didn't bring any cash 'cause he said he was treating. It's not like we shouldn'ta known better."

As the five of them made their way out of Lucy's, Butch pointed to a framed headshot high above the last table near the door. "There he is," he said. "Marlon fuckin' Brando. The greatest of all time!"

"We know, Butch, you point him out every time we leave," Johnny said.

The crowd had thinned out by now, and although there were a few tables left, no new customers were coming in. The last table on the left by

the front door hadn't been cleared and was littered with half-empty plates of beans, tortillas, half-consumed margaritas, Dos Equis, and other assorted Mexican-dinner detritus. Duke was leading the way out, and Butch was slowest and last. His high had just about worn off and he was feeling mostly tired. But he stared at the Brando headshot, mesmerized.

"Tonight she is mine," he said with an exaggerated matador's flourish of arm and hand. He walked over to the table, cleared out a place on the tabletop, stepped on the chair and then onto the table, and yanked the Marlon Brando photograph off the wall.

"Tonight, she is mine!" he repeated. A waiter in the back near the kitchen yelled out, "Hey, get down from there!" and the five of them ran out the front door laughing. William and Duke turned right and ran toward William's VW. Johnny and Bonnie turned left, holding hands and laughing, running toward Romaine Street, Bonnie careful not to drop her guitar. Butch followed. "Tonight she is mine," he yelled, clutching the cheaply framed headshot of Marlon Brando to his chest, stumbling and laughing while he ran. "Tonight, she is mine!"

Stella

6

I Miss Y'all

Been so long since I've been gone,
But look out now, I'm 'bout to hook out home
Because I miss y'all, yeah, I miss y'all, hey I miss y'all
Woo . . .
Going to the land of the plentiful lips
Where those beautiful women swing their bountiful hips
Back down where I can come to grips, and quit going off on all 'a them trips
And all . . .
Yeah, I miss y'all . . .

THE YEAR 1969 FOLDED INTO 1970 in a grass/tobacco/beer/gin/Jack
Daniels/pizza/musical instrument/hamburger/donut haze.

"Man, I can't do another Christmas in this sumbitch," Butch said. "Last
year liked to kill me. It's already the seventeenth, and you wouldn't even
know it was December to look around here."

"It's not exactly like we have a white Christmas at home, you know,"
Johnny answered.

"Yeah, but at least people feel like it's Christmas, and sometimes it gets
cold. Here it's just the same goddamn thing every day—74 degrees and
sunny. This is trippin' me out. Let's go, man."

"Well, I told Ferd I'd work through the twenty-second and that's next
Tuesday, so I can't leave until at least Tuesday night."

"Well, fuck that, I'm hitchhiking home," Butch said, and he let fly
an empty bottle of Miller High Life, which hurtled end over end until it
clanged the rim of the white trash can in the corner of the small bedroom
on Romaine Street. They were each lying on a twin mattress on the floor

on opposite sides of the room. "And I'm tired of living like fuckin' hippies," he added. "At least at home I can sleep in a bed."

"If you were a little better shot with your empties, we wouldn't have beer bottles all over the fucking room, and don't do me any favors about waiting for me 'cause I know the way home too, you know."

"Well, fuck it then, I'm gonna smoke a joint and hitchhike home this afternoon."

"Man, just wait 'til in the morning," Johnny said. "You can get up early and get a fresh start. I'll ask Ferd if I can leave on the afternoon of the twenty-first, and I'll be home on Christmas Eve. I'll meet you at the South-downs Lounge. I'll be sitting at the bar."

"OK, hoss, that sounds like a good plan," Butch said. "So what are we doing tonight?"

"Bonnie's got a folk gig at a little club in Reseda, so I'm driving her there."

"Reseda? Man, that's the opposite direction from where I'm going. That's north; I wanna go south."

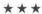

Johnny worked until the twenty-second, just as he'd promised. Ferd let him take off early so he got on the road out of L.A. about two in the afternoon. Butch had been gone for four days and was probably home by now, but Johnny hadn't heard from him. He decided to take the southern route back to Baton Rouge through San Antonio and Houston. That way he could listen to XERF in Del Rio for at least twelve hours. He'd made the drive before in thirty hours, so his plan was to take a "Black Molly" about fifteen hours out, say about three in the morning of the twenty-third. That way he'd be good to go for the rest of the fifteen-hour pull and get to Baton Rouge about nine or ten in the evening. Perfect. And with XERF he got Wolfman Jack and great blues and R&B to distract him. XERF gave its city of license as Del Rio, Texas, but the tower and transmitter were actually in Mexico. The Mexicans didn't regulate tower height or power so there were a couple of monster stations on the Mexican side of the border. The

stations were on a clear channel, and with their 100,000-watt transmitters and 1,500-foot towers, you could hear them all the way to Canada. Just east of Phoenix, he began listening to the Wolfman. The Wolfman played great records—"It's All Over Now" by the Valentinos, and records by the Kelly Brothers, Nappy Brown, and occasionally Elvis—and he howled like crazy when he played "Chantilly Lace" by the Big Bopper. Johnny loved it, and the drive time flew by. When he crossed the New Mexico/Texas border he was in great spirits and wide awake. The "Molly" had kicked in, and combined with the coffee it made him feel alert and excited. He made a mental note not to grit his teeth.

The West Texas pull was always the hardest, no matter whether you did it from El Paso to Dallas or El Paso to San Antonio. Long stretches of empty road made your mind wander, and that wasn't good. Besides, the rain, which had started out as a light sprinkle, had grown to a full-blown winter thunderstorm and was pelting the front windshield of his van. The driver's-side wiper worked fine, but the passenger's-side blade had dry-rotted, and the metallic scrape of the blade was irritating and was scratching the windshield. Johnny slowed down as he approached an intersection near Van Horn, Texas, trying to make sure he got on the right road to San Antonio. He saw what looked like two hitchhikers in the driving rain and was going to pass them by when he realized one was waving a bandana and holding a bottle of beer. "Damn," he thought, "that guy looks like Butch." He slowed to get a better look and then slammed the brakes, bringing the van to a sliding stop. He leaned over and rolled down the passenger's-side window. "Butch, is that you?"

Butch leaned his head into the van and laughed. "Man, where you been? I been waiting for you here for two days. You running late, John Raymond."

"Get in, goddammit. Man, you've lost it."

"Hey, what about my man Cal here? He needs a ride too."

"Who the fuck is Cal?

"He's my man Cal. He's traveling with me."

"Well both of y'all get in."

Butch jumped in the passenger's-side door, and Cal slid the van's side door open. They were soaked and both their duffels were soaked. Johnny shook his head at the mess and put the van back in gear. "I think I have a towel back there somewhere if you guys want to dry off a little," he said.

Butch jerked back over the seat and looked into the back of the van. "Cal, this is John Raymond . . . the best sumbitch in America."

"Pleased to meet you, John Raymond," Cal said, "and thanks for stopping for us."

"Just call me Johnny. John Raymond is what this nutty motherfucker calls me, but most people just call me Johnny. What have you guys been doing?" He looked at Butch.

"We been smokin' a little grass, chasing a little ass, showing a little class, and breaking a little glass," Butch said.

"Oh, right," Johnny said, "you've been being Butch—fucking up on the way home. Looking for mischief, looking for trouble, getting drunk, getting stoned, picking up Cal."

"Say, John Raymond, don't knock my man Cal. He's a good dude."

Cal was about Butch's height but wiry and fidgety. He alternately chain-smoked Camels and pot. He had a pencil-thin mustache that made him look like a Mexican movie star. "Man, I'm glad you showed up, John Raymond. I was tired of being wet," Cal said.

"Just Johnny . . . not John Raymond. John Raymond's a Butch thing. Just call me Johnny."

"OK, dude, don't go all trippy on me. From now on it's plain Johnny, you can bet your ass on that."

Butch broke in: "Let's smoke a joint, Cal. You want to, John Raymond?"

"Naw, I'm just the fuckin' driver here, and I dropped a Molly a little while ago and drank my weight in coffee, so I'm fine."

Cal poked around in his duffel looking for a joint. Butch was acting freaky in the front seat, touching the window crank, opening and closing the glove compartment, picking at the floor mat. A few moments of silence passed while Johnny looked back and forth from the road and the rain to Butch.

"What?" Johnny said.

"What what?" Butch answered.

"I know that jumpiness means something. What is it?"

"Well, I don't have any cash, and I don't have a Christmas present for my momma. I was wondering if you'd spot me a couple a hundred 'til we get back to L.A. and I'll go do some work on the boat and pay you back."

"I don't have a couple of hundred to loan you, and if I did I'd be crazy to do it 'cause you piss all your money away doing shit like this."

"I know how we can get some money," Cal blurted from the back of the van. And instead of a joint, he pulled a gigantic, long-barreled .357 magnum from his duffel. "Let's rob a fuckin' bank," he said.

The dark metal of the gun barrel took on a sheen from the reflected dashboard lights. Butch and Johnny looked at each other and back at the gun and then back at each other.

"Goddamn," Johnny said. "Goddamn, Cal," Butch said, almost in unison. "Put that goddamn thing away," Butch continued. "You're freakin' me out here."

"Put that thing up," Johnny joined in. "We're not robbing a fucking bank, and I'm gonna put you out if you don't put it up."

"Whoa, motherfucker," Cal said. "Can't we have a conversation about it? I got a good plan: we'll rob one of these small-town banks when it opens this morning, drive on to Houston, get a motel, and cool it 'til it dies down. And you can't put me out 'cause I got the motherfuckin' cannon, and you're just the fuckin' driver. You said so yourself."

"Cal, put it away, really. Now you're making me nervous," Butch said.

"OK, but let's have a little mutual give-and-take about decisions here. I want to feel like I'm part of the solution, not part of the problem," Cal said, and he put the gun back into his duffel and continued to root around in it for the joint. "I got it, Butch, but it's kinda wet. Still want to try it?"

"I don't believe, Cal," Butch answered. "Let's just chill and drive for a while."

Johnny stared straight ahead. He reached over and turned the radio up louder. Wolfman was howling over Bobby "Blue" Bland's "Don't Cry No More." Butch reached into his bag for a dry bandana. He wiped his face

and tried to dry his hair. No one spoke. The scratching of the worn out right-side windshield wiper blade was almost in perfect time with "Don't Cry No More." Johnny grit his teeth.

After a few minutes of tense silence, Cal announced his intention to take a nap. He tilted over on his side and put his duffel under his head for a pillow. The felt presence of the .357 magnum was strong and dangerous. Butch was stoned, drunk, paranoid, wet, and nervous.

Johnny drove into the hard rain. The flash of an occasional set of on-coming headlights outlined his face. He stared straight ahead, not looking at Butch or back at Cal. The rhythm of the music and the windshield wip-ers was joined by a low-pitched growl from the back of the van. Cal was snoring.

About an hour and a half of hard driving passed in absolute silence. The sun was up about ten degrees on the horizon, and the rain had stopped. The early-morning sunlight was a yellowish-white that illuminated the in-side of the van with stark contrasts, making everything seem harsher and more brittle. Johnny looked at his hands on the steering wheel. They were flushed red from squeezing it so hard. He looked over at Butch: "We gotta get gas pretty soon." Butch said nothing. They passed a billboard: *Stuckey's Pecan Logs and Texaco, 3 miles.*

"I'm stopping here," Johnny said. "I'll go in and pay for the gas and take a leak, you pump it, then I'll come out and you can go in." The bump of the van onto the shoulder of the highway shook Cal in the back. He woke up fully when Johnny came to a stop at the gas pump. "What're we doing?" he said, still groggy.

"I gotta get gas, and we both have to use the men's room," Johnny replied.

Butch turned back to face Cal. "Why don't you start pumpin' and we'll get the inside stuff done and get some beer and something to eat; then you can go."

Butch and Johnny got out of the van and walked across the small park-ing lot to the Stuckey's. Johnny gave the attendant a ten-dollar bill. "For that van out there, as much as that will buy." He looked out at Cal at the gas pump and gave him the thumbs up. Cal started pumping the gas, and

Johnny walked to the restroom and caught up with Butch at side-by-side urinals. The restroom was dirty. There was toilet paper all over the floor and a broken air dryer on the wall.

"Those things never work," Butch offered, "so people all wipe their hands with toilet paper and trash up the men's room. If they put paper towels in here, they'd save a lot of labor cleaning the place up."

"What are you, an efficiency expert?" Johnny replied. "Why don't you think of an efficient way to get rid of that crazy bastard with the gun who wants to rob a goddamn bank while you're at it?"

Butch looked over at Johnny and then down at the urinal. The smell of road and beer and piss and vomit overwhelmed the restroom. "Stinks in here."

"Really?" Johnny said as sarcastically as he could. He exhaled an exasperated sigh and said, "Butch, you can get us into some real jams."

"Shit, let's just leave the skinny bastard when we trade off," Butch said. "Let's just drive off and leave him."

The restroom door banged open, smashing into the opposite wall and startling Butch and Johnny. "I'm already done," Cal said as he surveyed the mess inside the restroom. "Ten bucks didn't fill it up even. Goddamn, this place stinks."

"That's what we've been saying," Butch replied, "and if they put some paper in here to dry your hands, the place wouldn't be so messy. People get pissed off and wipe their hands with the toilet paper, and that's what makes the mess."

"Please," Johnny said with a disgusted shrug. "Sorry, Cal, I've heard this speech already," and he turned to walk out of the men's room.

"I'll be right out, guys. Butch, get some beer," Cal said.

Butch was right behind Johnny as the restroom door closed.

"Let's hustle, asshole," Johnny said back over his shoulder to Butch.

"Wait, I want some beer," Butch said.

"Beer? You better get your ass in that van right now."

Butch and Johnny got to the van door just as Cal was coming out of the restroom. He heard the crank of the engine and realized that he was about to be left. He started a clumsy run toward the gas pumps.

"Don't leave me, Butch, you son of a bitch!" he shouted. "Don't leave without me."

Johnny was panicked trying to get the van started. It finally cranked just as Cal made it to the front door of Stuckey's. He floored it and was heading straight for Cal when he made a sharp left and wheeled the van back toward the road. Butch was leaned over the seat laughing convulsively and rummaging through Cal's duffel. "Hurry up, John Raymond, the little sumbitch is gaining on us." The more Johnny struggled to get the van back on the highway, the harder Butch laughed. Meanwhile Cal was close enough to Butch's door that he could almost get a hand on it. Finally the van started to put some distance between Cal and them. Cal was shouting: "Butch, you no-good son of a bitch! You asshole, Johnny!" He was spitting and gasping for breath. Butch rolled down the window and tossed Cal's bag out onto the shoulder just as the big yellow van lumbered onto the highway.

"See you down the road, big boy," Butch shouted out the window. Cal caught up to his duffel, quickly unzipped it, and pulled out the .357. He took aim at the van's back windows. Click, click, the revolver barrel rolled through the chamber.

"You sorry son of a bitch, Butch," he shouted at the receding van.

"Laugh, asshole, laugh away," Johnny said. "Another one of your asshole adventures."

"Aw, John Raymond, that wasn't so bad. Besides he was nice to me when we were stuck in Van Horn." Butch let the .357 cartridges slip from his right hand to his left and back again like a Slinky toy. "We've been in a lot tighter spots."

"Man," Johnny said in exasperation. "Man."

They didn't say much between Houston and Lake Charles. Just driving and watching the sprawl of refineries, careening tanker trucks, and the countryside change from barren and wide-open West Texas to wet and swampy East Texas and Louisiana. Going over the bridge from Westlake to Lake Charles, Butch looked over at Johnny. "I'm not going back, man. I'm not going back to L.A. I'm gonna stay in Louisiana."

"What about trying to get a demo budget or acting or anything else that you said you wanted to do?"

"I'm just going to do it from down here. I don't like L.A. anymore."

"Whatever, but there's no music business down here. If you want to be in that business, you have to be in L.A."

"Well, Hank Williams and Elvis did it, so maybe I can too."

"Excuse me," Johnny jumped in quickly, "let's don't compare you to Hank Williams and Elvis.

"I wasn't. I was just saying . . . it's not impossible."

He looked over at Butch and saw a wet and disheveled, sleep-deprived man-child with a three- or four-days' growth of beard, jet-black hair matted in clumps to his head, and a facial expression that said, Why not?

"Whatever," he said.

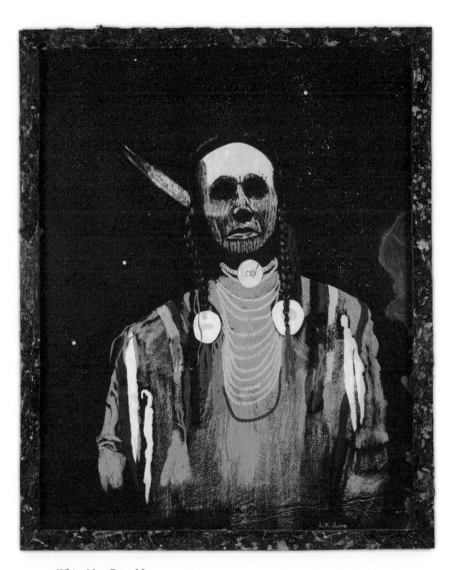

White Man Runs Me

7

Room to Rock

Come on over by the club babe,
I will do my latest smash,
Don't tell your momma that you're coming,
I know your people think I'm trash.

Oh, if there's room to rock,
We will rock tonight,
You can catch me on stage at the Hound Dog lounge tonight . . .

THE TELEPHONE RING WAS MUFFLED. Butch had shoved the phone between the mattress and box spring he had set up on the floor. It was a pink Princess telephone, the kind Southern Bell marketed to teenage girls. He was living in a little shotgun house he called his garret in the shadow of the new Mississippi River bridge in Baton Rouge. The sun came up directly into the only window in the all-purpose front room. It was three in the afternoon, and he was still trying to sleep. He'd gotten home at daylight and still wasn't sober or sleeping, just in a fitful alpha state of borderline consciousness. He tried to ignore the ring, but it persisted, on and on, like the person calling knew him and his ways. He finally rolled over on to his back and angrily yanked the little telephone from its hiding place.

"What?" he asked.

"We got a deal, man. We got a budget and a deal with ABC Paramount." It was Johnny. "Artie just called me, and we got a sixty-thousand-dollar production budget of which you can take fifteen grand off the top. I get five of it, you keep ten, and we use forty-five grand to make your album anywhere you want to make it. Are you hearing me, man? We hit a fuckin' home run."

46

Butch tried to process the announcement through his semi-conscious fog. "Say it again . . ."

"I said we got a deal at ABC Paramount. Sixty grand . . . of which you can keep ten."

The business realities, though usually of little interest to Butch, began to register. "That's good, man, that's really good. We got a deal," he mumbled into the phone.

"That's right," Johnny said. "Now you can really sing, 'Oh Johnny, go get the money.'"

"So what do we have to do now?"

"Well, first we gotta get the contract stuff done, then you need to decide who you want to produce it, then we need to get it done and get it out. The contract part shouldn't be hard. It'll be a standard form, and it'll show Artie's cut and all, and you'll have to agree to deliver the album in a certain amount of time—you know, regular stuff like that." Johnny talked fast, trying to gloss over the fact that Artie's cut was part of the arrangement. Butch, however, was struggling his way up to clarity, and the words "Artie's cut" began to echo and resonate in his head.

"Whoa, John Raymond, whoa! What's the 'Artie's cut' part?"

"Well, he just gets a percentage of the deal off the top, like a commission. It's a standard thing. We're lucky he got the deal at all."

"I know, and it's really good that he got it and all," Butch said, "but just how much is Artie's cut?"

Johnny thought for a minute before responding. He knew Butch would see through anything but the raw, unvarnished truth. He waited until the silence got a little painful and finally blurted out: "Well, the whole deal is for a hundred grand, and Artie gets 40 percent off the top. But it's worth it 'cause without him, we wouldn't even have the deal at all."

Butch listened and reflected on what he had heard. He was sitting up on the side of the mattress now and reached for a half-empty bottle of Miller High Life stored on the floor since dawn. It was hot in his little house, and although the sun was behind his back wall now, the beer had been pretty much cooked over the course of the day. He stroked his forehead back and forth with the side of the bottle and finally responded, "He

gets 40 percent?" He took a big sip of the hot beer. "That little fucker gets 40 percent?"

"Yeah, I know it's a lot, but he got the deal, so it's worth it," Johnny said. Think about it this way: 60 percent of something is worth more that 100 percent of nothing."

Butch waited a beat.

"Yeah, yeah, yeah, that's Cy's line, but the fact remains that the record company is willing to pay a hundred thousand dollars for my music and that little bastard gets forty thousand of it before it leaves the goddamn building. Something about that doesn't work for me, John Raymond. I'm fuckin' sorry, but something about that just doesn't work for me."

"Man, you're blowin' my mind. If it wasn't for Artie, we wouldn't have the goddamn deal, and if you don't want it and you don't want the chance to record your album, then fuck it, don't do it. I don't give a shit if you do or you don't. You're holed up in some ratty-ass shack in Baton Rouge, and this son of a bitch went to bat for you and got you the money to make your record, which by the fuckin' way, is what you say you want to do, and you're gonna freak out about the fact that he gets paid for working for you? What are you, some kinda nutwagon? It's always like this with you, Butch. Always some sinister motive behind the scenes or something. I've had it. I don't give a fuck if you do it or not. Fuck you and all the goddamn complicated shit that goes with trying to help you." And Johnny slammed down the phone.

Butch listened to the disconnect tone in his little pink Princess . . . beep, beep, beep. He took the final sip of the hot beer and flipped the empty bottle in the direction of a small trash can in the corner of the room. It bounced off the edge and joined several other empty bottles that had missed the target.

"Go-a-odamn," he said out loud, stretching it out like a stretto in one of his songs. "We got a fuckin' record deal with ABC fuckin' Paramount. Go-a-odamn."

★ ★ ★

Butch got his advance check from ABC Paramount. It was a very official-looking document printed on currency-colored watermark paper. It bore two very official-looking signatures, a precise and legible "David Black" and another that looked like scratches. When he held it up to the light, he could see some security engraving. It was made payable to the order of Charles E. Hornsby, p/k/a "Butch" Hornsby, and Butch thought that was a nice touch. He folded it neatly into his top pocket and drove down Highland Road to 235 Burgin Street, the little house Cy was renting while in law school. Butch veered off the driveway and into the yard so as not to block the VW hatchback Cy used to transport his pregnant wife and two-year-old daughter. He walked up to the front screen door and yelled, "Anybody in here?"

"I'm here, Butch, come on in."

He opened the screen door and let it flap behind him and walked the five or six steps through the small living room and kitchen to Cy's study. As usual, Cy was seated behind his large desk, studying a law book.

"I got it, bro," Butch said, "all fifteen thousand dollars of it right here in my pocket."

"That's great, Butch. Now I just need to get you to do the right thing with it."

"Yeah, you right, man, and that's why I'm here. I'm gonna take your advice. I want you to take this check and set me up with an account, and I want to save it and make investments with it, maybe a bank CD or something like that. You know all that stuff."

Cy was finishing his last year of law school, and he was also going to produce Butch's album. Butch thought Cy knew all about law and business and music and was willing to trust him with not only the production of his masterpiece but also the handling of his money. Butch reached into his pocket for the check, and, as often happened in moments like this, his eyes welled with tears.

"I love you, man. I trust you more than any sumbitch on earth, and I know you'll do right with my money. Besides, we're gonna make a hit record, and there'll be money all over the goddamn place."

"I hope so, Butch, I really hope so. You've written powerful enough material, that's for sure."

Butch took the folded check from his pocket and spread it out upside down on Cy's desk. "Look at that man, fifteen fuckin' thousand dollars, and we don't have the first note recorded. I want you to take this and do something smart with it for me, 'cause I'd go buy a pickup truck or something with it, and I know you'll do something better." He began to cry. "I love you, man . . . I trust you. We're gonna make a hit record and I'm gonna make something outta myself other than a fuckin' ironworker."

Cy got up and walked around the desk to Butch. In that awkward, self-conscious way that men try to support each other during emotional moments, Cy put his arm halfway around Butch's shoulder and said, "I'm flattered that you trust me, Butch, and I'd never do anything to betray that. And look," he said, reaching down to pick up the check, "you endorse this and I'm going to put it right here on this shelf like a trophy, and first thing tomorrow morning I'll go to the bank and get all the papers to get you set up with a savings account, and we'll put some in a checking account and put you on a budget that can sustain you until you start getting some record royalties."

Butch scrawled his name on the back of the check and handed it back. Cy made a small ceremony of putting it up on a shelf by the front door. He moved some books and photos around and put the check in a place of honor in the center.

"There it is, man," he said, "the first of many, we hope."

"There it is, man," Butch repeated, "the first of many."

Butch backed out of the driveway and retraced his path down Burgin Street, turning right on Highland Road and heading back to the chaos of his downtown house. He felt oddly mature and conservative. He drove through the LSU campus and past a gauntlet of fraternity bars and liquor stores that fronted Highland Road. Behind this wall of college-age merriment was a large and growing population of poor black people. Tensions would rise and fall between the two groups over the next ten years until the frat boys finally packed up and moved to the other side of campus. But

for now, it was a Potemkin Village of good times, practical jokes, and the mandatory liquor and sex rites of passage for the overwhelmingly white, middle-class LSU student body. Butch passed the Bengal Lounge, one of his favorites, and about a block past he made a hard U-turn and went back. He parked in the rear parking lot and walked around to the front door under the suspicious stares of a couple of black teenage boys. He walked into a cacophony of clanging pinball machines, pool balls bouncing off one another, and the high-pitched din of the TGIF celebration of the Sigma Chis, who had made the Bengal their unofficial hangout. Their dates, the majority of whom were Chi Omegas in some preordained pairing similar to an arranged marriage, were all stamped from the same mold: blond hair in flippy bouffants, turquoise eye shadow, bright red lipstick, and fit, slightly plump bodies. That was why Butch liked the Bengal.

His entrance didn't cause a stir exactly—he wasn't Sigma Chi. He wasn't interested in the fraternity thing when he was enrolled at LSU, and he couldn't concentrate on school anyway so he never stayed in longer than a semester at a time. But, though his entrance didn't cause a stir, he looked good enough in his tight jeans and flowery cowboy shirt that some of the Chi O sisters did take notice. The bartender and owner, Steve Bonfanti, was a buddy of Butch's. "Hey, Stevie," Butch shouted, "gimme two fingers of Vodka in a number-three washtub . . . and a Miller High Life back."

Getting drunk took a lot of time—and a side trip. When Butch finally stumbled to the parking lot behind the Bengal for the last time, it was well past three in the morning. After a few fumbling attempts to put the key in his truck's ignition, he finally got it in. The pickup wouldn't start. He tried it a few more times, then glanced down at the instrument panel and realized he was out of gas.

"Fuck," he said and slammed his palms onto the steering wheel. He pushed open the driver's-side door so hard that it bounced back off its hinge and slammed into his shin as he turned to get out. Butch rattled off a string of expletives even longer and louder than usual. He fumbled around

in the bed of the pickup and found a gas can. Powered by whiskey and the pouty red lips of the Chi O sisters, he took the empty gas can and ran back down Highland Road past the Wienerschnitzel hot-dog franchise, the bank branch, and the supermarket to the Tiger Shell station. He handed the cashier two dollars and weaved his way back to the pump.

Two dollars' worth of gas almost filled the can, and hauling it back to the Bengal Lounge was a lot harder than his sprint to the station. The Bengal was closed when he made it back. Everyone was gone, the lights were off, and the rear parking lot was dark and a little scary. The two black boys were still hanging around, and they watched Butch as he struggled with the fuel cap and the gas can. He poured about half the gas from the can into the tank, capped the can, and threw it into the bed of the pick-up. He walked around and got in the truck, struggling again with the key until he found the ignition hole. The truck cranked and groaned, but it still wouldn't start. He got out of the truck, grabbed the gas can, opened the hood, and poured some gas directly into the carburetor, thinking that would prime it. No luck.

He got out and shouted to his audience of two black teenagers, "Shit and piss and fuck and—hey, y'all know any other good cuss words?" He kicked the driver's-side door. "Why won't you start?"

After about thirty minutes of trying everything he knew about starting stalled vehicles, his frustration peaked. He took the gas can and poured gas onto the seat of the pickup, splashing what was left on the hood and into the bed. He fumbled around in his pockets and found a book of matches. He lit one and threw it on the seat of the truck. When the match hit the gas-soaked truck seat, it burst into flames with a loud "shwoosh." Butch backed away from the burning truck. The two boys were laughing and slapping their hands together and bending over.

"Mufukka burnt his own fuckin' truck," one said to the other. "Jeesus," the other answered. "Mufukka burnt his own truck."

"Start next time, asshole," Butch said to the truck. "Fuckin' start next time."

★ ★ ★

Cy woke up the next morning at quarter to eight. He looked at the clock on the bedside table to confirm that he had slept in. He hadn't come to bed until two the night before, trying to cram in his constitutional law case readings, and he had slept soundly and deeply past his usual 6:30 wake up. His wife was still sleeping, and his two-year-old girl was standing up in her crib at the foot of their bed staring at him. "Shh," he said, as he put his finger to his lips and whispered, "Mommy's still sleeping. I'll get you some juice." He bent over to give her a kiss as he made his way to the kitchen. Cy thought she was the most beautiful baby girl ever—and so did Butch. Butch had already given her the nickname "Millie France," which he repeated to her over and over in a florid French accent.

Cy noticed something wasn't right as he walked through the living room. It was cooler than it should be, as if a door had been left open. He looked up on the shelf—Butch's check was gone. The kitchen door was wide open and the screen on the back porch door had been cut just above the lock.

"Son of a bitch," he said. "The son of a bitch broke into my house and stole his own check. Son of a bitch."

The sessions went great. Better than Cy or anyone else expected. Butch was in fine voice throughout, and, with overdubbing and varispeed, the engineers were able to keep him in time and on pitch. Cy had assembled an A-list of players and techs. The engineers, Tommy Couch and Wolf Stephenson, had produced and engineered some monster hits. Their venue, Malaco Studios, was an unassuming metal building just inside the Jackson, Mississippi, city limits and across from a rail yard. Inside, the studio was a cocoon of carpeted walls, movable baffles, small soundproof booths with windows, and various pianos, B-3 organs, Fender amps, boom mike stands, and mikes. Tangled cables strewn across the floor led back to the control room. The control room had a large, angled glass wall with a sofa just in front of the console and two giant Altec Voice-of-the-Theater speakers mounted in either corner. Behind the console were tape machines, out-

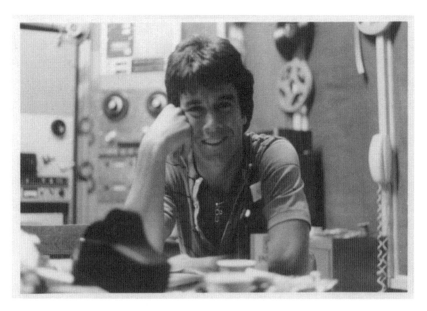

Happier times at Malaco Studios

board processing gear, and another sofa separated by a door that led into a small break room. Wolf and Tommy and Mitchell Malouf, the founders, had recorded some of the most soulful albums of the era, along with great singles hits like "Misty Blue" by Dorothy Moore, "Who's Making Love to Your Old Lady (While You Were Out Making Love)?" by Johnny Taylor, and dozens of other R&B and gospel classics. Malaco had a rhythm section that rivaled the best of the southern studios.

The first of those legendary studio rhythm sections was at Cosimo's in New Orleans in the late fifties and featured Earl Palmer, Allen Toussaint, Deacon John Moore, Frank Fields, and others. Malaco had comparable heavyweights, but the studio players at Cosimo's, like Earl Palmer, had created many of the conventions of the genre.

Earl Palmer invented the foundation of the genre—the art of rock 'n' roll drumming. He invented the use of triplets and a backbeat on slow tunes. He invented the use of syncopated bass drum figures alternating with a powerful backbeat on the two and four of the measure on up-tempo tunes. And he invented the end-of-phrase fills that would provide propul-

sion and energy for the whole song. His invention would go on to be copied and used by hundreds of thousands of musicians and recording artists around the world and to be embraced by listeners in Great Britain, France, Russia, Brazil, Japan, and China—everywhere that American pop music has been enjoyed, admired, and copied.

James Stroud on drums and Carson Whitsett on keyboards formed the nucleus of the Malaco section, and they could cover any kind of track, from the most soulful gospel all the way to redneck Mississippi/Alabama country. James was a huge talent and an energy force field in the studio who would go on to a very successful producing career in Nashville. Butch fascinated James, and his interest would continue later in Butch's career. But during these sessions he kept everyone light and laughing, especially Butch, with his imaginary alter ego, Delta bluesman Ironin' Board Sam, whose make-believe hit was called "I Kissed My Baby in the Swamp." Whenever they hit a rough patch or were stuck for a chord or a beat, James would sing out in his deepest Delta Blues voice, "I kissed my baby in the swamp," and the impasse would be broken, the puzzle solved.

There were a couple of other rhythm sections in the sixties that achieved a similar lofty status. The Muscle Shoals Sound Studio band, in Alabama, featured players like Roger Hawkins, Jimmy Johnson, Barry Beckett and David Hood; and then of course there was Stax in Memphis with Booker T., Steve Cropper, Al Johnson, and Duck Dunn.

But on Butch's sessions, James and Cy alternated on drums; Carson Whitsett played piano and overdubbed B-3; Randy Jackson and Don Chesson, who co-produced, played bass; and Courtney Westbrook and Hal Ellis covered rhythm and lead guitars. Duke came in from L.A. to play rhythm guitar, double Butch's vocals, and sing the harmony parts. Butch wasn't real strong on doubling his own voice in harmony, and Cy didn't force the issue. It was a collegial production process, with Cy taking input from everyone and trying to filter up the best ideas and licks. After the tracking sessions and before he tried for keeper lead vocals, he brought in the Jackson Southernaires for some mellow, gospel harmony backing vocals, and the Memphis Horns for a little funk. The mood throughout was serious, professional, and determined. There wasn't much drugs or drinking,

and Johnny either paced back and forth in front of the lower sofa or was laid out on his back taking in the music and thinking about how much fun it was going to be to take this album back to L.A. and present it to Artie Wenrik and ABC Paramount. At one point during "L.A., Oh No!" Butch hit one of his patented high-C shrieks, and Johnny fell straight back over the arm of the sofa screaming, "This shit is good, Cy!"

As the tracking and overdubbing sessions began to wind down, Cy and Don and Butch would drive back and forth to Jackson in Don's old blue Cadillac. One night after a particularly long attempt to get a keeper vocal on "Room to Rock," Butch was drunk and stoned and mean. Cy and Don tried to be patient and get the vocal down, but it wasn't working. Cy was at the console and hit the push-to-talk button after interrupting in the middle of the refrain. "Butch, you want to wait and try this later? You aren't really finding the groove here tonight."

"Nah, man, let's go again. I'll get it." Butch was behind a vocal isolation baffle and had a headset covering one ear. He was listening to the studio playback with the other ear, and the microsecond time delay was throwing him off. Don got up from the sofa and walked over to the console. He leaned on the push-to-talk button. "Butch, either put the headset on both ears or take it off completely. It's screwing up your time."

"Fuck you, man," Butch said into the mike, and it boomed through the control room. "I know what I'm doing. This ain't my first fuckin' rodeo here."

Don released the push-to-talk button and looked down at Cy. "It most certainly is his first rodeo. He's an amateur."

"I read your lips, asshole," Butch blurted into the mike. "I ain't no chauffeur, and I ain't no amateur."

"All right, guys, let's just see if we can get this done," Cy said to Don and into the intercom. "Let's everybody just calm down and see if we can get this done."

Wolf looked up from the console. He'd been riding gain on the lead vocal mike throughout this frustrating series of takes and hadn't said anything. "Y'all know he's got a pint of Jack Daniels behind that baffle, don't you?"

"Well it's pretty hard not to tell," Don replied. "He's been sliding all over the pitch and the meter."

Cy pressed the push-to-talk button again. "Let's break for tonight, Butch. Wolf's gotta go, and we have to drive back to Baton Rouge."

"Sheeit, man, I got thish . . ." Butch slurred.

"Naw, let's go. I'm tired, and it's already almost midnight."

"Well, just fuck it then," Butch said and threw the headset down to the studio floor.

"Hey, lighten up on the equipment gunk-boy," Wolf said into the intercom. "You don't want to be paying for the Sennheiser headphones." He lifted his hand from the push-to-talk button and turned to Cy. "It's probably a good thing y'all are breaking now, 'cause I'm 'bout to walk out there and kick his ass myself," Wolf said.

Wolf was a big guy. It was rumored that he'd played football at Millsaps College, and if he didn't, he could have. Butch wasn't eager to take him on. Wolf set about to clean up the studio and power down the tape machines and the console. Cy and Don collected the demo cassettes, track notes, and lead sheets that were spread around the control room.

"Well, the track is great anyway," Cy said. "We'll get a lead vocal eventually."

Butch was pacing around the studio and in and out of the control room. By now, he'd killed off the last of the Jack Daniels. "Oh, Mr. Cy," he'd sing, "my oh my, oh Mr. Cy, gimme my pie, make no mistake, that's my cake," and he'd laugh out loud at himself and at the late-night petty larceny he'd pulled off to retrieve his advance check. After the break-in, he'd gone back to the Bengal and bought the remaining patrons whatever they wanted. Steve Bonfanti had given him a five-hundred-dollar advance against holding his fifteen-thousand-dollar check, and Butch spent it all that night on people he didn't know.

Don and Butch had another hostile exchange on the way to the car.

"Man, can y'all chill on the fighting for a while?" Cy asked.

"It's him," Don replied. "He's being a pain in the ass. I'll make his ass walk back to Baton Rouge."

Cy got in the front seat. Don got behind the wheel, and Butch piled into the back. The big Caddy lumbered out of Jackson, leaving behind the metal building, the 7-11s, gas stations, and rail yards that made up the studio's neighborhood. The first hour or so was uneventful. Don and Cy traded small talk about players, performances, arrangements, studio sound, equipment, mikes, and chicks, and Butch slept.

About forty-five minutes north of Baton Rouge on Highway 61, Butch woke up. He was still a little drunk, but the Jack Daniels was wearing off. Highway 61 was a two-lane asphalt road with curves and hills. A lot of people had died on this highway, and although Don was a good driver, he was driving too fast.

"I'm hot in this mothafucker," Butch said. "I'm rolling down the window." The wind rushing in the back window caused an annoying rapid-fire pressure change inside the car.

"Close the window, Butch," Don said.

"I'm hot in this mothafucker," Butch replied.

"Well, close it anyway."

"Awright," Butch said, "but I'm gonna open the door. I want to see how close I can get my head to the ground." Butch raised the rear window and pushed open the heavy rear door of the Cadillac. He leaned his head out and tried to see how close he could get his head to the asphalt. Don sped up.

"Don, please slow down," Cy said. "Butch, get back in the car, man."

Cy's law school experience forced him to do the liability calculus from torts class. If Butch's head hit the asphalt, it would splatter like a watermelon thrown from a window, and they would be liable for wrongful death if not negligent homicide. "Don, please, slow down." Butch leaned out even farther.

"I'm close, man, I can see the pea gravel!" Butch laughed hysterically.

"Don, come on, man, he's gonna kill himself. Slow down, please," Cy pleaded.

"Fuggim," Don said flatly.

Cy looked forward at the winding two-lane road. There was very little moonlight, and random headlights flickered in front of and behind them.

He looked back at Butch laughing maniacally with his head hanging out the back door, perilously close to the blacktop. Turning and wedging his way through the hole created by the tilt-down armrest, Cy grabbed Butch by his shirt and heaved as hard as he could to pull him back into the car. Pushed by the forward speed of the big Cadillac, the back door slammed shut as Cy yanked Butch inside.

Butch's wild laughter had subsided. He now wore the slightly guilty grin of a disciplined child.

"You a good sumbitch, man," he said to Cy, their faces about a foot apart. "But I knew what I was doing. I wasn't gonna get hurt."

Cy squirmed his way back through the armrest hole and settled back into the front seat.

"You know, man," he said, "sometimes you can really push people. Here Don and I are trying to help you get your album done, which, by the way, is gonna be great, and you do crazy stuff like that. Why don't you ever think about how what you do affects other people? Do you only think about yourself?"

"Other people are all I ever think about. I never think about me."

There was a stunned silence in the car as the vast expanse of polymer plants, PVC-manufacturing facilities, and the cracking towers of the giant Esso refinery in Baton Rouge came into view ahead of them.

Don lit a cigarette.

8

I Have Seen the Universe

Friendly bookies, hostile junkies,
Crooked lawyers, who ended up in Congress,
I know what the black don't like,
Better believe I can feel the bite,
I have broken up this earth
I call it home, I call it home . . .

Insane actors and stars in ignition
I know artists, who don't know recognition,
Living with the rats and the roaches,
Este tardes, buenos noches
I have seen the universe,
It looks like home, it looks like home.

"GODDAMMIT DAVID!" Artie Wenrik stood up and placed his palms on the glass expanse of David Black's desk. It was clear, clean glass protecting beautiful mahogany, and David kept it spotless and clutter-free. A multi-line telephone was neatly placed on the left corner, and David constantly unknotted the cord. He was vice president of A&R for ABC Records. He'd started as a salesman when the company was called Am-Par, and he was a protégé of its legendary president, Sid Clark. David knew the murky provenance of Am-Par, and though he'd made his reputation in the company as a salesman, his real talent was picking hits. He'd brought so many hit master-lease deals to the label from his fieldwork as a salesman that he was eventually named head of A&R.

"You're putting me on," Artie continued.

"Nope," David replied nonchalantly, "and don't smudge the glass."

"Don't smudge the glass? You're about to get fired, and I'm about to lose a ton of money, and you're worried about the glass? How did this happen? Who found out?"

"I don't know how it happened. Some boy lawyer back-tested the total contract amounts against the studio invoices, and the studio bills only totaled between 50 and 60 percent of the contract amounts. He ratted me out to Marsha Rubin in legal, and she confronted me. I just didn't have the energy to bullshit her, so I told her everything."

David Black's salary and bonus totaled between $300,000 and $350,000 a year. It was a lot of money, but not enough to support his lifestyle. So he had set up an elaborate system of kickbacks and deducts from the artists' roster that required the deal makers, the agents, and, indirectly, even the producers and artists to be complicit. Artie slumped back into his chair. Both men were quiet for a moment, looking out the large window of David's lavishly decorated office facing Beverly Drive.

"Well, what do we do now?" Artie asked.

"I'm getting canned this afternoon, and all your deals are kaput, out the door, done."

"All of 'em? The Karla Bonoff's gonna be a monster, and I got points in that."

"Gone. Pretty much every artist I signed except Ray Charles is out."

"Jee-sus, is there more downside here? Have we got any criminal potential? I bet Geffen or Irving Azoff end up with Karla's masters and I'm totally screwed on that."

"I don't know. It's up to Marsha, I guess. It could be just a civil matter as far as you're concerned. Me, I think I've got a problem, but I guess it depends on Marsha."

"Jeez." Artie let out a deep breath.

They were both a little startled by the buzz of the intercom. The familiar voice of David's secretary interrupted the silence. "Excuse me, Mr. Black, but Miss Rubin and a gentleman from the Beverly Hills Police Department are here to see you. May I send them in?"

★ ★ ★

"Miss Rubin? My name is Cyril Vetter, and I'm the producer of the Butch Hornsby album, *Don't Take It Out on the Dog*."

"I know who you are. What do you want?"

"Well, I wanted to talk to you about a possible buy-back of the master. I'd like to try to do something with it, rather than have it just sit in your vault."

"Oh, it won't sit in the vault, 'cause worse comes to worst, I'll erase it and reuse the tape."

Cy gasped and tried to regain his composure.

"Well, that probably wouldn't be the highest and best use for the tape, don't you think?"

"Let's drop the law school-isms here, Cyril. How much money do you have? 'Cause I'm not gonna give it away."

Cy waited a beat. He was afraid Marsha Rubin would blow him off just for the hell of it. She might think southern rock was just hick music, one guitar lick away from Confederate flag-waving, redneck hillbilly music. He'd better be careful how he framed his response.

"Well, we don't have a lot of resources. We were not aware of the arrangements between Mr. Black and Artie, and we produced our record and delivered it in good faith and on time."

"OK, I'll give you that," Marsha shot back curtly. "So what are you offering?"

"I can pay you five thousand dollars in cash."

Marsha laughed. "My company has a hundred thousand dollars and a wrecked A&R department in this tape, and you're offering me a nickel on the dollar? You must not think much of your album, 'cause a nickel on the dollar isn't nearly enough. Like I said, I'll erase the tape and reuse it before I give it away."

"Well, five thousand dollars is really all I can come up with. And the whole thing at ABC is such a mess, as I'm sure you're painfully aware. I read the article in *Cash Box*, and nobody wants to touch any of these masters, except maybe the Karla Bonoff, so I won't be able to shop it anywhere

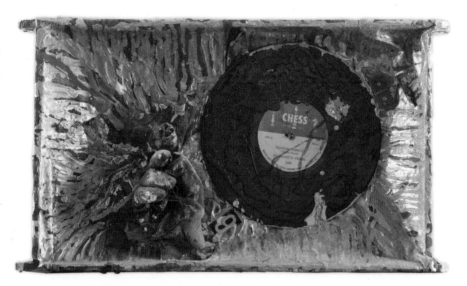

Record Bidness 2

else, and I'll have to release it myself, which is more expense. So, really, five thousand in cash is a lot more than I have and a real reach for me."

"Well, it's not enough. I'll let it go for ten thousand dollars just to get it off my list of unpleasant things to do."

"I just don't have it." Cy scrambled for ideas. "I can give you five thousand dollars in cash and a note from Butch for five thousand dollars against any record royalties if his record sells when I release it on my label."

"Oh, you know what? OK." Marsha was frustrated and wanted the conversation over. She had been embarrassed by the David Black incident. It happened on her watch and reflected poorly on her oversight of the contracts department. She knew she was probably out, not far behind David Black once all these civil and possible criminal issues were resolved, so she was motivated by a combination of regret about the past and fear of the future.

"Send me the check and the note, and when the check clears, I'll return the masters and the original contract with a cover letter saying it's been voided, and I'll send a mutual hold-harmless release for you and Butch to sign."

"Thanks," Cy said and waited through a space of uncomfortable silence. "I appreciate your cooperation on this. It's none of my business, but I feel bad for the situation you're in . . . just on a purely professional basis."

"Well," she thought for a moment, "that's nice of you to say. It's an unmitigated goddamn disaster, that's for sure. And really, I know that you weren't a part of it, so good luck with whatever you do with this master, and I hope you sell some records so you can pay the note part. We really need the money around here now."

"And good luck to you too. I really wanted to be on ABC Paramount. It felt like the right place for us."

"It's not a good place for anyone right now, so let's get this documented and get it over with."

"OK. I'll get on it right away, and thanks again."

"Right. I gotta go. I'm afraid there's more where this came from."

9

Suddenly Single

I've no idea love, why you never come home,
Two weeks ago Sunday, is how long you've been gone
I been sittin' here thinking, since you walked out on me
I must take advantage, of the fact that I'm free.

Suddenly single, as free as the wind, I'm sure this ring'll
Slip right off my hand
I'll go where there's music, I'll hang out with friends,
Suddenly I'm single, I'm single again.

CAROL AND HER FRIEND MARYBETH WALKED into Ruby Red's, a college hangout under the Perkins Road overpass. The Colonel's Club was just down the block, and it was where the LSU Greeks partied on the weekends and especially on TGIF, which featured live bands and went from noon until closing at two in the morning. So the area was always lively, even though the din of the massive car and truck traffic on the I-10 span above it was a little distracting. Ruby Red's was a copy of a place in Atlanta, and the interior looked like a rowdy frat house: people tossed peanut shells on the floor, carved their initials and graffiti into the tables, and thumb-tacked autographed dollar bills onto the soft-tile ceiling. Carol glanced over her left shoulder as she and Marybeth made their way to an empty table down near the end of the bar. She tugged on Marybeth's blouse and whispered, "There he is."

"There who is?" Marybeth blurted out, and Carol placed her finger to her lips and hissed, "Shhh, there's Butch."

Butch was everywhere in Carol's consciousness these days. She'd seen

his picture—tousle-headed in a casually posed full-body shot with a Fender Stratocaster slung petulantly around his neck—on the cover of *Gris-Gris*, the Baton Rouge underground newspaper. The shot was taken high in the Hollywood Hills, with the sprawl of Los Angeles laid out behind him.

"That's the man I'm going to marry," Carol said to Marybeth as they settled into a table across the noisy room from Butch.

"You don't even know him," Marybeth laughed out loud, "Carol Ann, you can say some silly shit at times."

"I know, I don't 'know him,' know him" Carol said, making two quotations marks with her fingers for emphasis, "but my horoscope said that he and I were meant to be together."

"How do you know the horoscope was talking about him? It could've been anybody. The people who write those things make them generic like fortune cookies so they'll apply to anybody."

"I don't think so, Marybeth. I believe it down to my last molecule. That man is in my head and my soul. I'm gonna marry him, all right, and that's it, end of discussion."

"O.K., whatever you say," Marybeth grumbled and looked down at her menu options.

Carol looked over at the table where Butch sat.

"It's a small town," she thought. "Our paths will cross eventually." There was something about Butch that touched her deeply. It was physical and palpable. Not looks necessarily, not manners or the way he handled himself, but something deeper, a vulnerability that all the jeans and cowboy boots and gruff attitude couldn't hide.

Butch and Cy and Duke and Johnny were deep into a serious conversation about Butch's upcoming gig. It was hard to talk over the noise in Ruby Red's, but Duke liked the burgers and there were always good-looking chicks around like the two who'd just walked in. Cy had released Butch's album on his own record label, the Record Company of the South (RCS). He'd wanted the label to sound big and corporate like RCA Victor or one of the majors, and he copied the original maroon color from the early Imperial record label to give it further credibility. As a child, Cy's favorite television show had been *Industry on Parade,* and in high school he'd doo-

dle letterhead stationery with radio and television station call letters and grandiosely named film, television, and music production companies. So the RCS label with a classic oval-shaped letter logo fell right in that tradition of fantasizing. "Suddenly Single," a lilting country ballad, was the first release from Butch's album, and it was getting some pretty decent airplay around the Southeast. In Baton Rouge, it was a smash—number 1 on the chart of the biggest country station in town—and the *Gris-Gris* cover story on Butch contained a very favorable review of the album. It didn't hurt matters that Cy had cobbled together some jake-leg financing to buy the paper, but he insisted it had "editorial independence."

"So Saturday we open for Hank Jr. at Shep's Club in Mansura. What's after that?" Cy posed the question to the table.

"Let's get through that first," Duke responded. "We've been rehearsing and it's going pretty good, but I don't want to look past this first gig. This is important."

"Rehearsals have been great," Johnny said. "The band is tight and they know most of the tunes from the album. I think the main question is whether we try to play all originals from the album or play some covers too."

Butch leaned back in his chair and balanced it on two rather flimsy back legs. He had a Miller High Life between his legs and a blue bandana around his neck. "I wanna do all originals."

"Well, right," Duke said, "that's the idea eventually, but for the first few gigs, we gotta play some Stones tunes or "She's Not There" or something like that just to keep the crowd in it. I don't think we can do all originals."

"I wanna do all originals," Butch repeated and came down on all four legs of the chair. "What's the point if we don't do my stuff?"

"The point is you're opening for Hank Jr.," Johnny said. "You're the opening act, and your job is to get the crowd warmed up."

"Yeah, leave them wanting to hear more of you," Cy said. "Just kinda tease 'em a little. Do "Suddenly Single" for sure, but do some stuff that they've heard before too so you don't lose 'em."

"Well, I wanna do all originals. They're coming to hear Hank Jr. *and* me," Butch emphasized. "I got a record out; I got a hit single. What's the point if we don't do my stuff?" Butch got up and walked toward the men's

room. He looked back over his shoulder and said to the table, "What's the point?"

Duke, Johnny, and Cy were silent for a moment. The chatter in Ruby Red's and the crunch of peanut shells accompanying Butch's footsteps were the dominant ambient sounds.

"Maybe he's right," Cy broke the silence. "This is his shot. Maybe we should let it all hang out and just do the whole album live. What's the worst that can happen?"

"Have you forgotten how many takes you needed to get a clean lead vocal?" Duke asked. "The worst that can happen is that he gets a snout full of Jack Daniels and slaughters his own songs. That, or he provokes some jealous boyfriend to make me jump off the stage and whip his ass."

"Well," Cy said, "this much is for sure. If he gets crazy drunk and you get in a bar fight, you'd both be doing what you love. So I ask again, what's the worst that can happen?"

Butch was nervous and antsy. He paced back and forth in the small dressing room off to the side of the stage at Shep's Club in Mansura. A typical big Cajun dance hall where drunk and sloppy fistfights broke out as often as waltzes, Shep's had 15,000 square feet of un–air conditioned dance floor with four big window fans on the left side of the hall and four big windows on the right. So the ventilation was good, even though the air being circulated was wet, hot, and vaguely swampy. And rightly so, since Mansura was about forty miles northeast of Baton Rouge across the massive Atchafalaya basin swamp, and to get there you had to drive across the Morganza Spillway, a Mississippi River flood outlet.

Like so many Cajun towns across the southwest and middle part of the state, Mansura had some great road names. Arno Gremillion Road, Lanson Bordelon Road, Johnny Coco Road, and T-Coon's Road were all eponymous routes to their respective owners' homes. Shep's Club was part of that Cajun tradition. It was part dance hall, part town hall, part restaurant and after-hours cockfighting pit. There was one like it in most Cajun towns. When

the traditional Cajun bands played, everyone danced with one another—grandmothers with their grandchildren, girls with girls, two girls with one boy, daddies with daughters, and so on. It was a real family thing accompanied by copious fried frog legs, crawfish etouffee, turtle sauce piquant, and boiled crawfish, all washed down with plenty of cold beer. It was a scene you could find only in South Louisiana. And the dialogue was a Frenglish patois that changed depending on who was listening: when outsiders were welcome in the conversation, it was mostly English; it was mostly French when they weren't. *Allons dancer à Shep's Club in Mansura* was a typical combination.

This gig was not a traditional Cajun dance so the crowd was different. It was younger, with fewer parents and grandparents. They were eighteen to thirty years old on average and a little more decked out and agitated than the typical Cajun dance-hall crowd. Butch picked up on the tension, and his pacing showed it. This crowd had come to see Hank Jr. and hear his hits. They didn't care about the opening act, and very few had heard "Suddenly Single." Duke sat on a ratty couch in the dressing room tuning his guitar and going over chord progressions with the other guitar player and the bass player one last time.

"Calm down, Butch, it'll be cool," he said to Butch, who was seated on the small step up to the stage.

"Oh, I'm calm, man. I just wanted to shoot the shit with Hank Jr." Butch had knocked on the door of Hank Jr.'s converted Greyhound bus only to be told that he was sleeping. Butch could see and hear some pretty raucous partying going on inside the bus, and he felt diminished and excluded at being turned away. "You'd think the sumbitch was Elvis the way he acts," Butch said. "I just wanted to talk to him about Hank Sr. for a minute. I hate his shit anyway. His daddy was the real artist. He's a hippie punk."

"Well forget it," Duke said. "I'm sure they've got a ritual they follow. Don't take it personal." He looked back up at Butch and added: "And why don't you cut back on that Jack Daniels a little? We want this gig to go great—in tune and in time."

Butch got up and paced to the back door. He opened it and looked out at the big Greyhound. He took the small bottle of Jack Daniels from his

back pocket and took a long pull. "Fuck him," he said, "we'll make these fuckers forget who he is anyway."

"It's show time—let's go," Duke said, and led the band up the steps and onstage. They were met with a smattering of applause, but mostly the crowd ignored them. Duke started with an instrumental version of "High Heeled Sneakers" that he finished with a snarky fuzz-tone guitar solo. Nobody danced and hardly anyone broke off their conversations to listen. When it was over, he walked up to the Shure 55 mike at center stage that Butch would use. "Testing, 1, 2, testing, testing, 1, 2. Can y'all hear me OK?"

His voice echoed throughout the hall, and he got a few nods and thumbs-up from a couple of audience members. He moved right to his mike, also a Shure 55, and repeated. "Testing, 1, 2 . . . mike check, 1, 2. How about now? Y'all hear me OK on this one?" He got the same tepid response. "Ladies and gentlemen, please welcome the recording artist of the hit "Suddenly Single," the dynamic Mr. Butch Hornsby." With that, he counted off a loud boot tap on the stage floor, "one, two, one, two, three, hey," and startled the house with a furious fuzz-tone guitar riff of the opening from "I Can't Get No Satisfaction." About four bars in, Butch hopped onto the stage holding a Miller High Life in his right hand and a blue bandanna in his left. He did an imitation Chuck Berry goose-hop up to the mike and let the guitar riff go for a full sixteen bars. He jumped in a little out of time with the first line but quickly caught himself and fell into a powerful and effective rendition of the smash hit. The crowd perked up a little bit, and when Butch prolonged the song well past the normal ending, he started to reel them in. Every time Duke would raise the neck of his guitar to indicate that he wanted the band to end it, Butch would start over with a guttural "I can't get no . . ." and Duke and the band would have to start over from the top. Butch took it as far as he could. He got the audience over to the front of the stage and held their attention for at least three complete versions of the song. Throughout the song, he was pulling bandanas from his back pockets and throwing them out into the crowd. On the fourth time around, the crowd began to get a little impatient. Clearly

they were beginning to form the collective notion that the lead singer was hyper or crazy or both. Duke finally refused to pick up the guitar riff again when Butch tried to get him to follow along.

"I can't get no . . . come on, man, I can't get no . . ."

Duke wouldn't pick it up, and he tried to laugh off Butch's antics. "Butch Hornsby, ladies and gentlemen," Duke said into the mike, "and he really can't get no satisfaction. Here's a cut from his latest album. We hope you like it." He counted off the intro to "Suddenly Single." Butch gave a great reading of his country-flavored ballad. Since it was a Cajun dance hall, a few couples tried to waltz to it but with little success.

When it ended and Duke and the bass player were retuning to each other, a gorgeous brunette in a starched white cowboy shirt and tight jeans pushed her way through the crowd and handed Butch a note written in bright red lipstick. Duke and the other band members laughed knowingly. The drummer looked over at Duke and in an exaggerated whisper said, "He's a chick magnet." Duke nodded.

Butch parodied the formal opening of a scroll as he unfolded the note. He looked down at the girl who had handed him the note, balled it up, and threw it at her. She caught it and threw it back. Butch stormed off the stage into the dressing room and out the back door. Duke sang one of his own tunes, "Bayou Country," which went over OK, but clearly the crowd was anxious to see the main attraction. Duke leaned over to the mike and said, "We're gonna take a short break. We'll be right back." He unplugged his guitar and walked in the direction of the stage door. He bent over to pick up the note and read it as he walked down the dressing-room steps. The gorgeous brunette, instead of giving Butch her number, had written "Get off. We want to see Hank Jr."

Carol pulled her little four-door Datsun off the street and onto the small patch of grass in front of Tommy Lorio's fence. She had her two girls, Ammye and Erica, with her. The youngest sat in a baby seat anchored in

two holes drilled into the rear deck between the seat back and the window, and the oldest was in the front seat with Carol. Inside, the car was a mess of textbooks, art supplies, food wrappers, and other assorted refuse that screamed out "single mom going to school and raising little children alone." Tommy had invited her over for dinner—he was such a dear person—and as she gathered up her purse and her girls she noticed an odd shape on his front lawn. It was a man. He had on cut-off blue jeans with no shirt and he was lying on newspapers, sunbathing. The sports section was folded over his face and he seemed to be asleep. Carol thought it odd—a person sleeping on top of newspapers in somebody's front yard, his face covered by a headline—very odd. She tried not to wake him up, but when she pushed on the fence gate it make a squeaking noise and the paper came flying off the man's face as he bolted up on his elbows. It was Butch!

"Hello, Slim, I heard you were coming. And who are little Helga and Olga there?" Ammye and Erica were both blue-eyed blondes, and Butch immediately tagged them with Nordic nicknames. "Tommy told me you and Stan weren't married anymore.

"Whoa, that's a lot to take in," Carol said. "I didn't think you'd remember me, I didn't think you would be here, and why did you call them Helga and Olga?"

"Well, I do remember you, and when Tommy told me you were coming over tonight, I invited myself, and your girls just look like they'd be named Helga and Olga. They're really pretty, classic Scandinavian types, and I thought they could use a little nickname."

"Well, I'm flattered that you remembered me. We only met for a minute."

"You made an impression on me. I've been keeping up with you through Tommy."

Carol fumbled around for a minute or so gathering up her girls and her composure. After all, this was Butch.

"I like your album," she said finally.

"Thanks, I like it too, but I think it's about to peter out."

"Why? I thought "Suddenly Single" was a big hit."

"It was a regional hit, but we didn't sell many albums, and my record company is pretty much tapped out on promotion funds."

"That's too bad. I think it should be a hit everywhere."

"Well, I think so too, but you and me don't write the *Billboard* charts."

"We should."

Tommy pushed the screen door on the porch open and said to Butch and Carol, "Y'all gonna have a private party out here, or are you coming in? I got fried chicken."

Butch pretended to herd Carol and the girls into Tommy's one-bedroom house. "I love fried chicken, don't you, Slim?" he asked Carol.

"I really do," she replied.

Tommy's fried chicken wasn't much. It was soggy and the batter was falling off. Butch and Carol were polite, but eating it was tough going. Even Tommy finally gave up. "This ain't much," he said. "I thought I could do it, but it's not very good."

"Did you soak the chicken in milk before you battered it?" Carol asked.

"No, I just rolled it in some cornmeal, like I thought you were supposed to."

"Well, it helps," Carol offered, "if you soak the chicken in milk before you batter it."

"I didn't have any milk."

Carol thought for a minute. "Look, the Winn-Dixie is just around the block. Why don't I run over there, get a cut-up chicken and some milk, and we'll start all over?"

Tommy laughed. "If you've got the energy for that, go for it."

"OK, I will," she said.

"And I'll go with you," Butch said. "I want to see how you do it, so I'll help." Butch and Carol walked out to her car. He was very caring and helpful getting the girls loaded. He put the baby in her carseat while Carol helped her older daughter into the backseat. "OK," he said, "we're all loaded up and ready to roll."

Carol started her car and slowly pulled out onto the street. Butch had put on a shirt and some Adidas sneakers with no socks. He looked at Carol

and then turned to the girls in the backseat. An instant wave of empathy enveloped the little car. "Man," he said, "this feels like a family to me."

Carol smiled. She felt it too. "You may be right, Butch. This does feel like family."

It didn't take her long. She got milk and two cut-up fryers and made her special batter and soaked the chicken in the milk before she fried it, and it was delicious. Butch and Tommy devoured it. She encouraged Butch to try it with a little honey and some salt and pepper, and it was even better that way.

"I've never had honey on fried chicken before, Slim—this is sooo good. You can fix this for me every night for the rest of my life," Butch laughed.

Carol's fried chicken was a big hit. Bigger than Butch's album. And it was the first of many of the small bonds that accrete between two people over the course of a lifetime together. Whatever disappointments, fights, disagreements, mishaps, or tragedies befell Carol and Butch, a supper of Carol's fried chicken with a little honey, salt and pepper, and some Louisiana hot sauce made most of them go away.

They made a life together. Butch did ironwork, played the occasional gig, kept it together most of the time except for an occasional tumble from the wagon, and they were happy. They had a little house on Capitol Heights Avenue in Baton Rouge, and although the summers were hot, the rest of the year was pleasant, and they enjoyed their time together. Butch was a wonderful surrogate father to Carol's girls, and most of the time he was a solid, caring man. The times he did fall off the wagon were brief and manageable, and Carol found a way to put it in perspective. In the big picture, she felt, the fact that he got drunk and mean every now and then was an acceptable joker in the hand that she was dealt.

Once, on a Friday night after Butch had spent a long week working on a high-rise iron job, he and Carol had finished a dinner of tuna fish sandwiches and he looked at her and blurted out, "I'd like to screw your friend Marybeth."

"You'd like to what?" she said. She felt her anger building even as she tried to control it.

"No, really, I think she's cute and I'd like to do it with her."

"You sorry, scary bastard. You live with me and my children and you say something like that?"

"Aww, you know, I'd just like to try it."

"Get out," Carol said. "I can't believe you said that to me. I thought you loved me and that you and I were together. I want you to go away. I'm done with your fits and tantrums and binges . . ." She was crying. "I just wish you would go away."

"Aw, c'mon, Slim . . . I'm just bullshittin'," Butch said.

"You're always just bullshitting, so take your bullshit and go away and leave us alone. We were fine before we met you, and we'll survive without you. You're a cold, mean, uncaring SOB."

"Well, fuck it then," Butch said, his voice rising. "Fuck it all. I don't need two kids that aren't mine and a bitchy bitch that can't take a fuckin' joke. I was kidding, but now I'm not."

The argument escalated way out of control, and turned into the most serious disagreement they'd ever had. Carol was reacting to more than Butch's tasteless joke. She was tired of his ups and downs—tired of them, but not really ready to end it all. For his part, Butch was rebelling against another authority. "I don't need this," he thought. "I'm fuckin' Butch Hornsby. I'm a fuckin' writer, I'm a singer, I'm a fuckin' star. Why am I letting myself be browbeaten by a woman with two children just 'cause I like her fried chicken and she makes me feel wanted? I can feel wanted at a fuckin' bar!"

"OK, bye," Butch said and walked purposefully toward the front door. "I'll see you cats later."

"Where's he going, Mom?" Ammye and Erica asked, almost in unison.

"Don't know, don't care, girls," Carol said. "We'll be just fine by ourselves, just like we've always been."

"But Mom, it's Butch," one of the girls said, Carol didn't know which. "We don't want him to leave."

Butch made his way out to the truck, pulled the door open as hard as

he could, and slammed it shut as hard as he could. He was parked on an angle to the little driveway, and he floored it as he backed out, leaving tire tracks in the yard. He made a violent cut back on the steering wheel, found the driveway traction, and backed up into the street. He jammed a forward gear and floored it again to get away as fast as he could. He hadn't planned to look back, but he did. He glanced into the door-side rearview mirror just long enough to see Carol bring a load of his clothes from the closet and dump them unceremoniously into the front yard.

That really made him mad. He screeched the little pickup to a stop, found reverse gear, and backed up as fast as he could to parallel the front yard. He got out, retrieved his clothes, threw them into the back of the truck, and peeled out again. Unfortunately, he glanced in the rearview mirror just in time to see Carol plop down another load of his things in the yard. He hit the brakes as hard as he could and backed up at full speed to the front of their house. He stopped, gathered up the things Carol had thrown out—this time it was books, records, and letters, things they'd shared!—and drove off again.

It didn't stop there. He made still another abrupt stop, backed up, clumsily gathered up the newest batch of things Carol had thrown into the yard, pitched them into the back of the truck, and roared off again. By now the drama was attracting attention. A neighbor cutting his grass stopped to watch, and an elderly woman across the street came out on her front porch. Butch had peeled out again, but before he reached the stop sign on Capitol Heights Avenue, Carol had run out into the yard with another load. This time his anger evaporated. Instead of getting mad and backing up as fast as he could, Butch started laughing. This was ridiculous. He couldn't remember how it started or why. What he remembered was her spirit and her independence, her fried chicken, and the way she loved her girls. He remembered her comforting embrace when he was drunk or sad or pissed or depressed. He backed up slowly this time. He stopped in front of the little house and yelled as loud as he could: "Hey, Slim! Let's get it all done with the next trip so I won't have to keep backing up and down the street. I'm not in a hurry. I'll just wait until you get it all done."

She kept coming out with armfuls of their personal things. After four more trips, she sat on the steps and put her head on her knees.

"You done, Slim?" Butch asked, with a little laugh.

"Yes," she said, "and I think that's the end of us."

"Well, I hope not," Butch said, "'cause I think *us* is a pretty powerful word. But if that's what you want, that's what we'll do."

He got back into the pickup, and he wasn't laughing anymore. He drove off. And he thought that he and Carol were over.

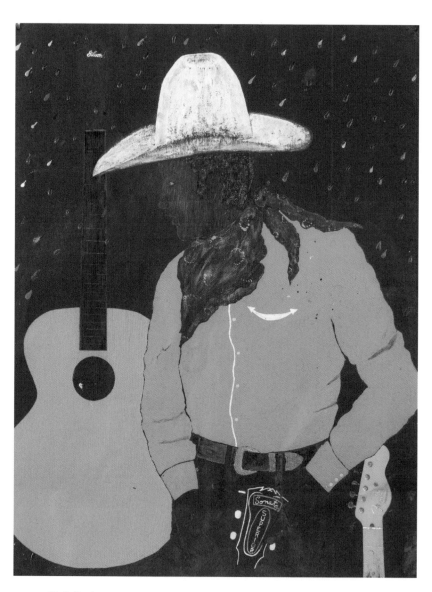

Pink Cowboy

10

Five Lost Songs

BUTCH CRADLED THE TELEPHONE. "Hey, Slim, you wanna go to Nashville?"

Carol was in the kitchen, scalding baby bottles and nipples and pacifiers.

"What? I can't hear you. The water's running."

Butch walked from the living room to the kitchen. "I said, you wanna go to Nashville? I just hung up with James Stroud, and he wants me to come to Nashville to work with him. He's doing more than just studio sideman work these days. He's producing, and he's got a development deal with Warner's. He wants me to be his first artist."

"Well, I love to travel and I've never been to Nashville," she said, "so yeah, let's go."

Neither could recall how they had gotten back together. There hadn't been any cathartic moment or crying reunion. Over the course of about three months they hadn't had much contact until one night Butch called and asked for her fried-chicken recipe. Ammye and Erica (Helga and Olga) had been asking about him—was he ever coming back? She glanced at them sitting on the floor coloring as she began to give Butch the recipe. She said, totally matter-of-factly and not really caring whether he did or didn't, "Well, if you want to, you can come over and I'll make it for you . . . if you want to."

He came, and they resumed their lives together as if nothing had happened.

And they were never separated again until he died. There was never any other love interest, passing fancy, or crush for either one. There were fights, always when Butch was on a drinking binge—"demonic drunks," Carol called them. There were dark times and lean times, even times when Butch was mean to her, but never for long and never enough to make her stop loving him. She told him once, "Not even you can be shitty enough to make me stop loving you." He laughed and immediately began to apologize profusely for whatever he was doing at the time, and the fight was over. The next morning while she was bathing and Butch was shaving, he stopped in mid-stroke and looked at her back as she was seated in the tub. "I guess you want to get married then," he said. She laughed and turned around to look at him. His face was half covered in shaving cream and he had a huge smile. "I swear, Butch, you can come out with some bizarre comments," she said.

"Well, don't you?"

"I do, I guess, but don't you think this is a kind of peculiar way to propose?"

"I'm not proposing, I'm saying let's get married. You get out of the tub right now and we'll get married." He didn't finish shaving; he didn't even wipe the shave cream off his face. He helped Carol out of the tub, wrapped her in a towel and ran into the kitchen to get a broom. He laid the broom down on the floor of the bathroom and walked around it and took Carol's hand. "Now, when I count to three, we're gonna jump over this broom and we'll be married." Carol laughed a little nervous laugh, but she knew he wasn't kidding. She squeezed his hand. "One, two, three," he said, and together they jumped over the broom. The noise they made landing on the wooden floor surprised them both. "OK, we're married now," he said, putting his hands on his hips in an exaggerated gesture, "and I'm the boss!" They laughed and kissed and she smeared the rest of the shaving cream all over his face and in his hair. But they were married, all right. Richer, poorer, better, worse, sickness and health, etc., etc., 'til death do us part, amen. Later, when they were in their forties, Butch's aunt Julia, a justice of the peace, would preside over an "official" marriage, but as far as they were concerned, they were married from the moment they jumped the broom.

★ ★ ★

A lot had happened since then. When she first got pregnant, Butch hated the idea. He screamed, "I'm gonna run into the woods," his usual response to anything that frustrated or irritated him. But he warmed to it when Carol started showing, and by the time Rio was born, Butch was totally consumed with the prospect of having their own baby. He loved Carol's girls like his own, but Rio was their baby together.

For Carol, Butch's insistence that they do things together opened a whole new world. She was still healing from a loveless marriage to a man who hated "having" to do things with her, and she loved being included. Butch wanted to do the dishes together and go to the grocery store together. After Butch died, she would say to friends and family, "I don't mind not being married, but I miss being included."

So their first child, Rio, was an infant; Carol was pregnant again, this time with Marlon; and they moved to Nashville. They weren't accustomed to four seasons. In Louisiana, the four seasons were Almost Summer, Summer, Summer as a Son of a Bitch, and Rainy. In Nashville, they had snow, autumn, spring, summer. They found a small duplex apartment near Vanderbilt, close to Music Row. An elderly lady lived in the adjacent apartment, and she only cooked outside. That fascinated Butch, who joined her every afternoon on the little shared back porch to watch her cook at her small bar-b-que pit. She loved the attention.

Butch brought people into his circle very quickly. He also befriended the mailman. He made a point to be at home every day when the mailman came so he could kid him about looking like Abe Lincoln. "Abe, I hope you got something for me today, 'cause I need to communicate!" He would say, "You know, Abe, people all call me the long-distance king," singing a line from his song "It's Real." And Abe would laugh and ask Butch to sing the rest of it. Like the elderly lady next door, Abe enjoyed being acknowledged.

Butch began to work with James, and they were planning a five-song session that would be the first side of Butch's album. James was excited. He'd call Butch, and if Carol answered, he'd give her a detailed account of

how the songs were developing and how strongly he felt that Butch's album would be a breakthrough for country music.

"Hey, Carol, it's me," James said on one of his regular Monday-morning calls. "I haven't heard anything like this since I've been here. It's a whole new style, like a combination of Hank Jr., Jerry Lee Lewis, and Little Richard. I think he's going to blow people away."

"That's great, James. He's right here. Let me get him for you." Carol liked James. He was a strong man with a good heart, and she could tell he believed in Butch's music. It helped, in the brief but intense moments of doubt she had about Butch, that a man like James Stroud thought he was talented and had a future. She handed Butch the phone.

"Ironin' Board Sam, you old son of a bitch," Butch barked into the phone, "talk to me."

"Man, we're all set," James said. "I've got the best session players in town loaded up for your session. Carson Whitsett and Steve Conn on keyboards, Emory Gordy on bass; I'd play drums myself, but I think I can do better being on the board, so I've got Russ Kunkel. It's gonna be an event. Everybody I've scheduled is on fire about playing on your session. I've played 'em the demos we made, and they love 'em." Butch listened.

"You know, most of the time," James said, "session players just play for scale and show up and do what they do. This time, they've heard the demos, and they're all really excited about playing on your album. Really, this is the easiest time I've had organizing a session. They all love your music, man. You should be flattered."

"I am flattered, James, and I can't tell you how much I appreciate that you want to be involved with me. Shit, man, you're Ironin' Board Sam . . . you kissed your baby in the swamp, you the man, and we're gonna make a killer record." They made plans for another rehearsal and hung up.

"Man, James is really fired up about this," he said to Carol. "I've never seen him so excited."

Butch was excited too. He had a manic energy that worried Carol a little, but mostly he seemed controlled and focused.

One morning when James had a dentist's appointment and they couldn't work, Butch left the house about eleven. Around four in the after-

noon, Carol began to worry. Her anxiety built until around six thirty, when Butch staggered in. Carol was sitting on a beanbag chair in the middle of the living room nursing Rio.

"Honey, where've you been?" she asked.

"None a' your goddamn business," he said, drunk and belligerent.

"Well, this is not good. I'm pregnant, we have a baby, the girls are with us, and they get scared when you're drunk. This is not good."

"I don't give a shit what you think is good." He stormed into the kitchen. "And where's my goddamn supper?"

His tone reminded Carol of an incident at Butch's parents' house in the country that she recalled vividly. They were at the kitchen table having lunch as Carol was being introduced to his family. Butch's dad, Lester, a gruff, hardscrabble country farmer, was seated at the table with Butch and Carol, and Butch's mother, Leota, was serving each one as though she were a waitress.

"There's not enough goddamn sugar in my goddamn tea," Lester said. "How come?"

Carol was stunned that a man would talk to his wife that way. Here was Leota, breaking her back to make everything right for everyone, and he was demeaning her. And Butch's tone was just like that . . .

"I haven't had time to fix any supper, honey. I've had the baby and the girls to look after, and I've been worried about you." He walked over to where she sat and lifted his right leg to the level of her head. He had on cowboy boots, and he put the boot heel on her head and gave a push. It wasn't extreme, but it was a push, with his boot heel to her head.

She got up and put Rio down on the beanbag. She walked past Butch into the kitchen. Butch walked over to Rio and started playing with him and cooing and making baby sounds. With a flip of the toggle switch, his hostility was completely gone. Now he was the loving, caring Butch, playing with his baby boy—the polar opposite of the cursing, violent person who had just stormed in.

In the kitchen, Carol opened the fridge door. There wasn't much in it. She was hurt and mad. Butch had done something to her that he had never done before; he had touched her in anger. She picked up one of the

flimsy old wooden chairs at the kitchen table and walked back into the living room. Butch was crawling across the room on all fours trying to get Rio to laugh. Carol swung the chair down on his back as hard as she could, splintering it.

"You just kicked the wrong girl, Butch. I'll put up with a lot from you, but I won't get hit or beat up."

The chair didn't really hurt Butch—it was old and he was drunk. When he was like that you could drop a knife on his head from the roof and it wouldn't hurt him. He didn't get up from all fours.

"Damn, honey, I didn't know that would make you mad. I was just trying to get your attention. I'm sorry. I wasn't trying to hurt you. I wouldn't do that, Slim."

As much as Carol hated to respond to violence with violence, she had to let Butch know she wouldn't take physical abuse. That boundary was never crossed again.

James was hunched over the huge Neve console at 17 Grand Studios in the heart of Music Row. He was tinkering with the equalization effects on the drum kit and wanted to get it just right. "Try that kick drum for me, Tommy," he said to one of the studio techs. Behind a movable baffle, the tech stepped down on the bass-drum foot pedal.

"Not so hard, Tommy, I'm trying to round it off a little. I'm looking for a big, fat bass-drum sound this morning, and I don't want him to have to hit it too hard."

It was eight thirty, and the session was scheduled to start at nine. James wanted Butch to be at the studio at eight so he could meet the players as they arrived and get them laughing and in the right mood. It worried him that Butch wasn't there yet, but he kept to his preparation. Players began drifting in, getting coffee, tuning instruments, socializing, and swapping stories of gigs and sessions, dogs and wives. Every surface in the main room at 17 Grand was hard—wood, glass, or metal—so the footfalls and the conversations bounced around the studio like white noise.

Carson Whitsett was running scales on the baby grand piano when he looked at his watch and realized it was a little after nine. He stood up and leaned into the piano strings and spoke into the piano mike. "James, where's your boy? Aren't we supposed to start this thing at nine?" Carson's question silenced the din in the studio. It reverberated around in the control room and hung in the air. James looked up from the console. He pressed the push-to-talk button, which amplified his voice out into the studio. "He'll be here," James said. The volume on the talk-back mike was too loud and it distorted. They all ripped off their headsets, and Carson said, "Whoa, turn it down, bro."

"Sorry," James said and dialed back the console mike, "I said he'll be here. He's a little scattered sometimes, but he'll be here."

They went back to warming up or tuning or practicing. There was a big clock at the top of the control-room window and every now and then someone would glance up at it. About 9:15, Russ Kunkel got up from the drum set and made his way around the cluster of drums and cymbals and mikes and announced to the room: "I gotta make a phone call. Y'all come get me when we're ready." He walked out of the studio and into the little break room and lounge off to the rear.

James was alternating between anger and embarrassment. He couldn't believe the effort and time and money he had invested in this session, and Butch was late. He didn't know how he would handle it when Butch finally showed up . . . if he ever did.

Carson stood up and leaned over into the piano mike again. "James, you want us to put down the rhythm tracks now and you can do the vocals later?"

"Naw, let's give him a couple a' minutes. These tunes would be hard to do without a vocal track and a click track. Give him a couple more minutes. Maybe he had car trouble." James gave the console a hard shove, and he rolled back in his chair to the telephone by the outboard gear racks. He punched in Butch's number. Carol answered.

"Where the hell is he?" James asked. "I've got all these people down here at this expensive studio. Let me talk to him. This is costing a fortune."

"He's not here, James. He left about quarter to eight. I thought he was with you."

"Well, he's not here, and this is embarrassing me and pissing me off. I can't believe he would do this. Carol. I can't believe he would do this after all the work we've done."

"Something must have happened to him, James. Maybe he had a wreck, or car trouble."

"He had a wreck all right—he's wrecked everything we've been working on."

Butch pulled into the 7-11. He wanted coffee. He was already late. It was a little after eight, and James had wanted him at the studio by eight. He pushed open the door and walked to the coffeepot. He had to pee. He was nervous and he wanted coffee and he was in a hurry and he had to pee. He poured the coffee and decided he'd pee at the studio. He reached into his jeans pocket for some money and walked over to the cashier to pay for his coffee. A girl with a beehive hair-do was chewing gum and smoking a cigarette at the cash register. Butch put a ten-dollar bill on the counter and blew on his coffee. He looked up at the cashier and noticed a row of small bottles behind her.

"Y'all sell those little airplane bottles of vodka?" he asked.

"Sure looks like we do," she drawled.

"Well, give me as many as my change will buy," he said. "Taaka, that's the one I like."

She handed over four small bottles of Taaka vodka and some change. Butch shoved them into his jeans pockets and walked out to his car. He got in, started it up, and pulled out two of the bottles. He opened them both and drained them.

"Shit, that's nasty," he said to himself and opened the other two and poured them into his coffee. He backed out and onto Hillsboro Road in the direction of 17 Grand. The vodka in his coffee had cooled it and he drank it down. He was getting distracted now. That familiar feeling of spirits coursing through his blood and his brain distracted him. And he had

86

to pee worse than ever. He saw a sign made of two crossed pool cues for the Clean Break pool hall, boasting that it was where the Everly Brothers played pool, and he pulled into the parking lot. The pool hall was dark and dominated by a long bar with a few small pool tables in the back. "Y'all got a bathroom in here?" he asked the bartender.

"Yeah, but it's for customers only." There was a lone patron, and he and the bartender were huddled at the far end.

"Well, show me where it is in this dark-ass place and pour me a double Jack Daniels with a Coke on ice for a chaser."

The bartender nodded in the direction of the bathroom and Butch walked in. He pissed into a homemade tin trough, buttoned up his jeans, and walked over to the washbasin to wash his hands. He looked at himself in the mirror. The little bathroom was hot and stuffy, but he was shivering like he was cold. "Shit," he thought, "I'm gonna be late, and James is gonna kill me."

He walked out of the men's room and over to the bar. He reached for the Jack Daniels in an oversized shot glass and gulped it down. He drank about half the Coke.

"Damn, that's good," he said to the two men who stared at him like he was an alien.

"Lemme have another one just like that." Butch pulled out a wadded bunch of bills from his pocket and slammed them on the bar. "You work dog shift?" he said to the guy at the bar, "'cause it's mighty early to be drinking a beer."

"Nope," the customer said and continued to stare at him, "do you? 'Cause it's mighty early to be slamming Jack."

"Naw, I got a recording session I'm going to and I just wanted to lubricate my vocal chords a little." He drank the second double of Jack in a big swig and took a sip of Coke.

"Wanna shoot a game of pool?" he said to the customer.

"Sure," the man shot back, "but I hope it don't make you late for your *recording session*," putting great emphasis on "recording session," and the three of them shared a laugh.

After another double shot of Jack, a couple of beers, and three games of sloppy pool, Butch racked his pool cue and announced: "I gotta go to my session. Hasta mañana, hoss. I enjoyed it."

It was ten thirty.

Carson walked up to James in the control room. Everyone had loaded out their gear and most had left. Carson and Emory stayed behind to talk to James.

"Uh, James, we feel bad for you, man. We just had a little meeting, and we'll take a hundred bucks a man instead of scale. Emory and I both had other sessions we coulda' played, but we wanted to do this with you. We gotta get something, but we want to cut you some slack. I know this is a bummer and you're gonna lose your ass on it."

"Nope," James said, "I booked you guys. You turned down other gigs. I owe you, and I'm gonna pay you. It's my fault the thing didn't go off, not yours."

"Yeah, but we didn't play, so we want to be fair with you," Carson replied. "There'll be other sessions with you. We're just trying to be fair."

"Well, there will be other sessions," James said, "and they'll go a lot better than this one did, I can promise you that. I appreciate the offer. Let me think about it."

Carson and Emory walked out of 17 Grand and got into Carson's Volvo. "Man, that was a bummer," Carson said. "That's gotta be depressing when you try that hard for somebody and they do something like that."

"I hear you, man," Emory said, and they drove off down Seventeenth Street.

As they were driving off, Butch careened into the parking lot of 17 Grand and stumbled through the equipment entrance.

"Jimmy," he yelled, "Ironin' Board Sam . . . Where the hell are you? Where's everybody?"

Butch marched into the control room where James was in a hushed conversation with the studio owner and engineer about payment arrange-

ments for the session that didn't happen. He turned to look at Butch. He was a mess. He had pool chalk on his jeans, his shirt had come half untucked out of his jeans, and he was staggering drunk.

"Hey, where's everybody? Let's go, man, let's rock 'n' roll."

James excused himself from the conversation and walked over to Butch.

"Butch, you're two hours late and drunk. Those guys are professionals and they're busy. They don't have time for the *Ted Mack Amateur Hour*."

"Aw, man, I was just priming the pump, son, just getting in good voice. Let's go, man, let's make some rock 'n' roll history."

"Everybody's gone, Butch," James said with resignation. "The session is gone, I'm gone, your chance is gone—it's all gone. You've lost me. I don't want to talk while I'm mad 'cause I love you and Carol and I love your music, but I'm not doing this. There's too many other talented people I can produce without having to go through scenes like this. I'm sorry, I'm out."

"Aw, Jimmy, don't say that man. It won't happen again. You can count on me, old son."

"I'll see you later, Butch." James walked around Butch and out of the control room. He looked back over his shoulder and said to the engineer: "9:00 a.m. Friday, Jake. We'll start at 9:00 sharp. The guy's name is Clint Black. He's country, but he's good. See you Friday."

There would be other sessions, other very successful sessions. And James never regretted his decision about Butch. "Emotional Tar Baby" was where he filed his experience with Butch. It saddened him, but he didn't regret it.

Butch plopped down on the sofa near the equipment racks. "Carol's gonna kill me," he thought. "Shit, I don't need this," he said out loud. He reached over to the phone on the equipment rack and called home. Carol answered, frantic. "Butch, where are you? James called and said you weren't at the studio. Did you have a wreck? Are you OK?"

"Honey, let's start a lawn service," Butch slurred. "Me and you. We'll have a lawn service, and we'll work outside, it'll be fun. We'll have a ball."

Carol knew instantly what had happened. Butch had gotten drunk on the way to the studio and screwed up everything. Like James, she was mad

and disappointed. Butch had starred in another episode of what she called the serial sabotage of his opportunities. But in a crazy and incomprehensible way, she also felt a little rush of excitement that Butch wanted her to do something with him. She was included! A lawn service of all things, but she was included.

Tin Sheriff

11

Dirtdobber Blues

On a solo short flight, past an old country home,
On the gallery out front, hung an old Silvertone,
To the hole I was drawn, being born having wings,
Suddenly I'd flown, right in through the strings.

Inside so ideal, serene and then some,
But all had to yield to a powerful strum.
A rushing of wind, an emotional hum,
A blue song was sent, off some human tongue.

Dirtdobber blues, no bones and no blood,
To tell you the truth, my whole life is mud . . .

Out through the strings, in between strums,
Commence dobbing, past fingers and thumbs,
Carrying mix, working along, around dirty licks,
And among pretty songs
Minors and thirds and very sad words
Blue songs and new songs I never have heard

Dirtdobber blues, no bones and no blood,
To tell you the truth, my whole life is mud . . .

BUTCH MADE A FLYER for the Ready Lawn Service that showed a stick-figure couple holding hands and pushing a lawn mower, along with their phone number and the slogan *We're Ready* in a cartoon bubble above their heads. He took the flyer down to the Green Hills branch of the Nashville

Public Library and ran off about a hundred copies on an old IBM copier that the library let people use to copy pages from books so they wouldn't tear them out. On a Sunday morning, he and Carol stuck them under the windshield wipers of Lincolns and Cadillacs and Buicks in the parking lots of the massive Methodist and Baptist churches on Hillsboro Road. "No Chevys, Fords, or jalopies," Butch said to her. "We're only cutting rich people's lawns." They had no lawn equipment, and Carol had no idea how the plan would work.

Their first job came from an elderly couple with a beautiful old stone house on Golf Club Lane. The yard had gotten too big for the husband to cut, so his wife took the flyer from their windshield at church and called the Ready Lawn Service. On their way to the first job, Butch stopped at a Rent-All and rented a lawnmower, an edger, and a hedge clipper. It was a beautiful sunny day, and they had a great time. Carol mowed and Butch edged and clipped hedges, going back and forth to the car to check on Rio. Carol's girls played paper dolls under a big shade tree in the front yard near the car. The Ready Lawn Service wasn't what you could call a huge success, but they had a few regular customers. The Golf Club Lane house was their favorite, and they fantasized about one day having a house just like it. And when they got it, the lawn would be immaculate.

With an occasional check from Leota, a little money from the Ready Lawn Service, and some sporadic house-painting jobs for Butch, they were able to get by. There was enough money to buy groceries, pay the utility bills and the phone bills, and just make ends meet. Butch was on his best behavior—doting father, loving husband, caring neighbor. He helped the old lady next door keep her place tidy and shopped for her groceries when they went to the grocery store. Carol was happy. There was peace and tranquility in the simplicity of their lives.

Even James stopped by every now and then to check on them. He couldn't stay mad at Butch—nobody could. If Butch did something outrageous to you when he was drinking, he'd more than make it up with kindness and compassion when he wasn't. But James never had another conversation with Butch about recording. His visits were just personal, and they became less frequent as he became more successful. James confided

to Carol that he thought Butch was afraid of success—as long as Butch continued his self-destructive behavior, he'd never risk not being able to handle success. Carol thought it was a fear of failure—if Butch always sabotaged his opportunities, he'd never have a chance to fail. Butch could put hardships and bad breaks behind him, but he couldn't handle rejection.

Their time in Nashville passed with no more major blow-ups. He'd drink once in a while, mostly after working alone on a house-painting job. If he had a house-painting job and wasn't home by four helping with the kids and supper and doing errands for the old neighbor, Carol knew he was drinking. Butch was very punctual, never late unless he'd had a slip and fall.

They didn't have much in the way of a social support system in Nashville, though, and as Carol's pregnancy advanced, they began to worry about hospital bills and the fact that she wasn't able to work or help out. Carol's mother offered them a vacant rental house she had in Baton Rouge. Butch could do ironwork as a union man in Baton Rouge. It would be steady work with union medical benefits for the delivery, and they'd have family nearby to help with the kids. So they packed their belongings and Rio and Carol's girls and left Nashville. They also left behind Butch's dreams of a music career. He was done with it. He'd write a song every once in a while, but rarely more than a hook or a verse. Occasionally he'd finish a whole song and write down the lyrics and the changes.

"Potheads and fags," he'd laugh. "That's the music business, potheads and fags."

They moved into Carol's mother's house in the Goodwood section of Baton Rouge. Butch signed up at the union hall and began to do ironwork again. Life was pleasant enough in Goodwood. They knew some of the other young couples in the neighborhood, knew the break-ups and make-ups, the comings and goings, the pregnancies and babies, the dogs and cats, the lay-offs and promotions. Carol called it living in a soap opera. She and Butch observed it all with detachment, never really feeling a part of the life around them there.

One Sunday morning Carol walked into the living room while Butch was watching Jimmy Swaggart on a local TV station. She noticed he was

crying. She looked at the TV, and Jimmy Swaggart was crying too while singing an overwrought version of "Old Rugged Cross."

"Honey, we need to start going to church," he said to Carol. "Did you know that Jimmy Lee Swaggart and Jerry Lee Lewis and Mickey Gilley are cousins?"

"I think I may have heard that, Butch. But why do you have the urge to go to church all of a sudden? I never knew you had much religion, if any," she said.

"I don't know. I just think we ought'a start going to church. Swaggart's church. I like that preaching, and I like the choir and the singing too."

So they started going to Swaggart's Sunday-morning worship service. Butch would get all cleaned up and shave, and Carol would dress up in a floral maternity outfit and get the girls and Rio spiffed up and ready.

"We look like *Little House on the Prairie*," she whispered one Sunday as they filed into Jimmy Swaggart's massive World Ministry Outreach Church on Bluebonnet Boulevard in South Baton Rouge. He insisted that they follow the songbook, but his singing was barely audible. Carol leaned over to him in the pew and said, "I'm screeching like an alley cat, and you aren't even singing out loud. I thought we were supposed to sing out loud."

"I'm singing," he said. "I just don't want anyone to recognize my voice."

By 1986, contributions from the faithful were overwhelming the Swaggart operation. There was a whisper around town that the Swaggart Ministry averaged over $1.5 million in receipts every week, a combination of contributions, CD and videotape sales, and concert collections. Then there were the widows' wills and estate bequests and all the other forms of soul-saving, hope-filled gifts that began to amass into a real fortune. The Swaggart campus was expanding. He built state-of-the-art television production facilities, a Bible college, dormitories, and a recreation center, all a large and powerful testament to his ability to channel Jesus. He even had his own zip code!

The Swaggart family built a reproduction antebellum mansion compound behind huge gates across from the tony Country Club of Louisiana, and the whole spectacle began to generate grousing and resentment from the neighbors, the city, and his fellow televangelists.

But Butch went totally overboard. He wanted to go to Swaggart's church twice on Sunday, to sundown service on Wednesday, and to all the camp meetings and tent revivals that the Swaggarts conducted. He started quoting from the Bible and proselytizing all of his old musician and iron-working friends and anyone else who would listen. Carol thought he was craving healing and peace and that he embraced the Swaggart message as a substitute for drinking. She didn't care as long as he didn't drink, but Butch did alienate a few people when he insisted on quoting Bible verses.

Marlon was born and Carol was still nursing him when Butch told her he wanted another baby. It happened because one Sunday, in a bliss-ful moment of singing and praying along with the huge congregation in Swaggart's church, a little muffled cry made Carol turn around. She saw a young mother holding her baby up as if to the heavens, and it struck her as the most beautiful thing she'd ever seen. The baby was beautiful, and the mother was in a spiritual rapture with a perfectly peaceful and loving expression on her face. "Butch" she whispered, "look at that baby." Butch turned back to the scene of mother and baby and, like Carol, he was struck by the power of it. "Dang, Carol, we gotta have another baby," he said. So she got pregnant again, this time with Evan.

They kept faithful attendance at the Swaggart services. The singing, the shouting, the praying, the talking in tongues—they went for it all. And Swaggart's empire kept growing along with his power and visibility. These were heady times for the televangelists.

Butch and Carol, along with the rest of the congregation, began to worry when Swaggart started attacking other highly visible television preachers. Jim Bakker, the charismatic preacher from the Carolinas, was building a comparable empire, one to challenge Swaggart for the funda-mentalist Christian population as well as their pocketbooks. Bakker built a Jesus theme park, and he and his wife, Tammy Faye, were regular fixtures on local television stations around the country. The Bakkers and the Swag-garts and the other televangelists would buy the Sunday-morning time slots from the stations that broadcast their shows. The Swaggart shows were built around Jimmy's tearful singing and hell-fire and damnation sermons. The Bakker shows were just tearful, with the image of Tammy

Faye's dripping mascara indelibly etched into the consciousness of every God-fearing Christian soul who tuned in. Then the Reverend Bakker had the bad luck to get caught in a notorious "massage" peccadillo with an ex-stripper. Swaggart seized the opportunity to try to bring down his rival. He railed against him and "his ilk" from the pulpit every Sunday. He went on *Larry King Live* and called Bakker "a cancer on the body of Christ."

Swaggart accused a New Orleans–based preacher, Marvin Gorman, who competed for television time slots and donations, of using those donations to finance a lavish personal lifestyle involving gambling, drinking, and prostitutes, all the Old Testament taboos. In his sermons, Swaggart relished the chance to lash out in inflammatory biblical language at rival preachers, Catholics, Mormons, nonbelievers of any stripe. Butch and Carol didn't like it, preferring the old-timey singing and Gospel preaching services that marked their first contact with the Swaggart church.

Then the rumors began. It seemed that Jimmy Lee might have failings of his own. The rumors and the anxiety spread through the Swaggart church from person to person and from pew to pew. Gorman had pictures; Bakker had an affidavit; the elders of the Assemblies of God Pentecostal Church were going to defrock Swaggart and take control of his ministry; Swaggart had a teenage girlfriend; Swaggart had a teenage boyfriend! Each week the rumors got tawdrier. One Saturday in late 1986, the *New Orleans Times-Picayune* ran a front-page story alleging that the Reverend Gorman had hired a private investigator to follow Swaggart and was divulging the information he'd uncovered, first to the Orleans Parish District Attorney's office, then to the *Picayune*. The next morning the crowd in the Swaggart church was larger than ever; Butch and Carol couldn't even find a seat in their regular pew. Mixed in with the faithful church members were nosy, curious outsiders who shouldered aside the regulars for a chance to get the latest gossip. There were even some hippies there with pierced noses and ears and tattoos, giggling and snickering in the pews. Carol sat quietly while Butch, furious at the sacrilege, fumed at the interlopers. This was his refuge, his peace, the place where the cacophony between his ears was stilled. This was the place where there was no more resentment of his father for the years of slights, no more need for wild all-nighters, drinking

and self-medicating the pain away, no reason to rebel against authority . . . of any kind. And now it seemed to be falling apart.

Butch squeezed Carol's hand as the Swaggarts began to make their way up the stairs to the elevated red-carpeted riser that served as an altar. Frances Swaggart, steely-eyed and impeccably dressed, led the family; Jimmy Lee walked in the middle; and their son, Donnie, followed with his hand on his father's back.

The *Picayune* had indeed run the full story on the front page of the Sunday paper. "Swaggart with Prostitute," the headline read, and under it, "Gorman Says 'I Have Proof!'" The story detailed that Gorman had indeed hired a private detective, who photographed Swaggart entering a run-down motel on the Airline Highway in Kenner, a commercial/light industrial suburb of New Orleans. The paper even printed a time-line series of the pictures, clearly showing Swaggart opening the door of the motel room, letting his "friend" in, and looking back furtively over his shoulder to see if anyone had seen him. The story and the pictures were devastating. People were murmuring and whispering to each other: "Did he really do it?" "Y'all think those pictures are real?"

"Shush," Butch said aloud to all of those around him, "here he comes. Let him have his say."

The band started playing "Dwelling in Beulah Land," a soft, medium-tempo country-flavored hymn that was a congregation favorite. Normally Swaggart would count it off from the piano and lead the band through an instrumental verse before he started singing. He didn't go to the piano. Frances and Donnie sat down in large, purple-brocade satin armchairs to the right of the podium alongside a few rough-hewn men who were large contributors and elders of the High Church of Jimmy Lee Swaggart. Swaggart's eyes were puffy, and his cheeks were flush and swollen; he had been crying. He walked up to the podium he used as a pulpit and picked up his worn copy of the Bible. He bent the microphone tube down to the level of his mouth and cleared his throat. He held the Bible in his left hand, and it fell open to a place in the middle, a practiced gesture he used to connect himself all the way back through the narrative and mythology of Christianity to Moses. He held his left hand out for everyone to see. He coughed and

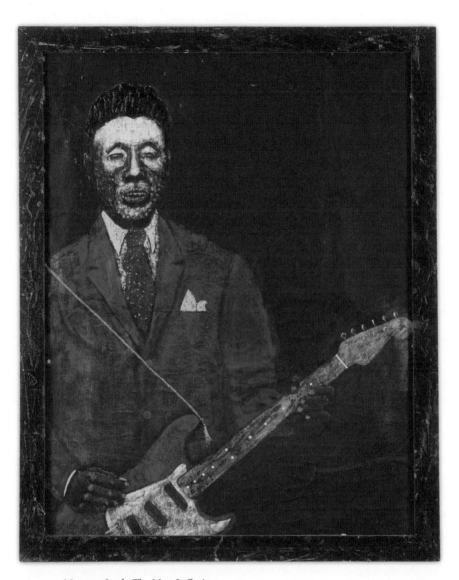

Mommy, Look, The Man Is Crying

cleared his throat again. Swaggart had a tic of clearing his throat and craning his neck as though the white shirt and tie he was wearing made him uncomfortable. He used the tic to make himself seem a man of the people, one of them. He only wore a suit and tie because a preacher was supposed to—he'd really be more comfortable in farmer overalls. He was, after all, a simple farmer who had been chosen by God to deliver the believers to the promised land, just like the simple carpenter a couple of thousand years before him.

"Some of you may have read in the papers about what I supposably done," he began softly, clearing his throat and craning his neck again against the starched white collar and choke-hold of the tie. "Well, I wish't I could tell you it was all a bunch of lies and evil rumors, but it's true. It's all true." The unbearable tension in the congregation was released. Swaggart started sobbing uncontrollably, and everyone in the church began to sob along with him, except the hippies and nonbelievers who came to witness his comeuppance.

"I have sinned against you, my Lord," he moaned and lifted his left hand with the open Bible toward the ceiling. "I have sinned against you, my Lord, and sinned against all these people in here today, and I would ask that your precious blood wash and cleanse every stain until it is in the seas of God's forgiveness."

"I'll be damn," Butch blurted out. He looked at Carol. She was crying. All around him people were crying. "Well, I'll just be damn." He and Carol were in a state of shock, along with the rest of the worshippers and a huge television audience. Swaggart was crying at the podium. He was close enough to the microphone so that his sobs and gasps for breaths were audible throughout the enormous auditorium. Frances Swaggart got up from her chair and walked to him. She put her arm around her preacher husband and escorted him off the riser, down the stairs, and into their dressing room. The band started playing an instrumental version of "Blood of the Lamb," and Donnie Swaggart, Jimmy's son and heir, moved to the microphone. The nonbelievers and the curious had already begun to make their way out, laughing and jostling each other. "I told you the son of a bitch was a fraud," a young Goth-dressed woman with jet-black dyed hair

and a pierced lip said to her companion. "A complete and total fraud, and all these gullible jackasses in here fell for it, hook, line, and sinker."

Butch and Carol and the rest of the true believers remained and waited for Donnie to speak, waited for somebody to say something to make it all make sense. Donnie adjusted the microphone.

"There will be Wednesday night Camp Meeting at the usual time, 6:00 p.m. in the Minnie Bell Swaggart Meeting Hall, and a Youth Ministry bar-b-que starting at 5:00 p.m. on Friday afternoon at the Jimmy Swaggart Bible College recreation area. Regular Sunday services will be held next Sunday, and with God's grace and the blessing of our Lord and Savior Jesus Christ, Dad will be preaching here next Sunday."

Butch had made Swaggart's firebrand preaching and singing a source of strength and a foundation for a life of relative peace and sobriety. "And here the sumbitch confesses to feet of clay," he said to Carol as they walked back to his truck, "human just like me and you and the rest of us."

The whole spectacle rocked Butch, and for a few days after that memorable Sunday he toyed with the idea of going to the Southdowns Lounge one night and just letting rip a monster drunk. But he had too much responsibility now. Rio was walking around, Marlon had been born, and Carol was pregnant again. Butch was starting to experience bad backaches, and he floated the idea to Carol of moving again, this time to the country near Kentwood to live in the house with his mother. He'd sing, "Route 1 Box 2, all right, but L.A., oh no" in a manic high-pitched voice to make his case to Carol. Leota was getting up in years and needed help, the country would be good for the boys, he could do some ironworking jobs and house painting, and Carol could garden and cook and sew. As usual, Carol was willing.

"Whatever you want to do, honey. I think we could have fun living in the country," she said to him, "I'll home-school the boys and you can be the principal of the school."

"Well, I guess I will," he laughed. "After all, I am the boss."

Carol's two girls didn't want to move to the country. They wanted to stay in Baton Rouge and live with their dad. Ammye and Erica were popular and cute, with a big network of friends. Their dad had remarried, and

he was doing better with his new wife, behaving and providing, so Carol agreed to let the girls stay behind. Besides, it was time for their dad to do something for his girls. Butch had let Carol's girls bring their dad's dying mother into their home, and Butch had personally cared for their grandmother during her last days, washing her face with a warm cloth, helping her sit up in bed, and feeding her. Ammye and Erica and Carol watched him do it, and it deepened and strengthened their love for him. Whatever Butch might do, they knew what was in his soul.

12

Queen of the Pines

Some roads might lead to Rome
The road through here leads away from home
It took my girl and now she's gone
Gone between the lines
She was Queen of the Pines . . .

I wish that I could learn new tricks
And leave this log truck stuck in this ditch
Looks like perfume and pine tar never will mix
I guess I've seen my time
With the Queen of the Pines . . .

SO THEY PACKED UP AND MOVED AGAIN, driving to Leota's little house in the country in the heat of the summer of 1988. The air conditioner in Butch's truck barely worked, and they were breaking all the rules about traveling with children: Carol was holding Evan, Marlon was on Butch's lap helping him drive, and Rio sat in the middle looking at the pictures in a Dr. Seuss book.

Things were good at Leota's. Rio and Marlon could run around in the yard, Butch worked when he wanted to and when he felt well enough, and Carol gardened and cooked and sewed. She got Butch interested in gardening, and he turned out to have a way with Creole tomatoes. He grew the juicy, acidy kind that made a great sandwich. Butch grew them, kept the plants watered and suckered, and Carol made the sandwiches.

One morning after they had been with Leota for about a year, she sat down at the kitchen table with Butch and Carol and said: "I'm moving to

your sister's house. These boys make too much noise." She looked at Rio and Marlon, who were throwing a biscuit back and forth at each other, and then at Evan, who was splashing the milk in his cereal with a spoon. "Y'all can stay here as long as you want, but I gotta go. I need a little peace and quiet."

Carol was upset. "No, Leota, we'll leave. We're not going to drive you out of your own home."

"Yeah, Mom, we'll go," Butch added. "This is your house. We're imposing on you. Boys, cut that out!" he barked at Rio and Marlon, and he took the spoon from Evan's hand.

"No, I'll go to Linda's," Leota said. "They're just being boys—that's what boys do. Y'all stay here. I want you to stay here and be close to me. I just want to go to Linda's for a while. It'll be fine. Everything'll be fine."

So they ended up staying in the little Hornsby family home out in the country near Kentwood. Jack, Louisiana, was the name of the settlement. It wasn't a town exactly, or a township or even a village. It was just a few houses on a country road that were known collectively to the locals as Jack, Louisiana.

Carol set up a classroom in the middle bedroom complete with desks and a blackboard. She had regular hours for class, and she taught the boys to read and write and some basic math. And whenever one or the other would misbehave or talk back to her or not do his homework, she would send them to "the principal." Butch took great joy in being "the principal," and his dialogue with the offender would always begin the same way:

Barely holding back a grin, he'd say: "Mr. Hornsby, your teacher tells me that you are misbehaving in class. Would you like me to beat you with a belt, or would you prefer that I beat you with a mule whip?"

"Mule whip, sir," was Rio's standard comeback. "The belt's for sissies."

Rio's difficulty remembering things as simple as the alphabet and with the most basic reading began to concern them. They thought the teachers at the Arcola First Baptist Church School might be able to help Rio learn, and they enrolled all three boys. Marlon and Evan breezed through the lessons, but Rio struggled there too. Carol helped around the school, which was run by four country women Carol always called "the little old ladies."

Sometimes she made lunch for the "little old ladies"; sometimes she drove to Kentwood for school supplies. His teachers worked hard with Rio, but his progress was painfully slow. They asked Carol and Butch to meet with them at the school. All six of them crowded into Mrs. Brascomb's tiny head-of-school office. Only Mrs. Brascomb spoke, while the other three teachers silently nodded in agreement.

"We think Rio has some learning disabilities," she said. "He's a good boy, and he tries, but he just has trouble remembering things, and he doesn't get numbers at all." The other three teachers nodded. "He's bright-eyed and alert and all, but he just can't seem to learn things." Carol and Butch weren't surprised to hear that Rio had a learning disability. And the Arcola church school just wasn't equipped to handle it.

One afternoon Carol was sewing in the front bedroom fretting over Rio when another troubling thought occurred to her. "Oh, my God," she thought, "I'm late. I should have started my period a week ago." She screamed out as loudly as she could, "Buuutch . . . honey! Butch, come here quick!"

Butch was out in his father's garage making a collage out of an old Barq's root-beer sign with Lester's tools, but he heard her scream and came running into the front room.

"What? What's the matter? Are you hurt? Did you stick yourself with the sewing machine?"

"Honey," she said, "My period's late. I'm never late. You know me, I'm the Big Ben of female periods. I think I'm pregnant again. Oh, my God." She put her head down on her forearm on the sewing machine table. "We can't afford another baby, and I'm forty years old. This will be my sixth child. Oh, my God, what are we gonna do?" She lifted her head from her arm to look at Butch. He was standing at attention like a soldier and he had a giant ear-to-ear smile.

"Didn't you hear me, Butch?" she said. "I think I'm pregnant again. What are you smiling at?"

"I want another boy, honey," he said. "I want to have four boys so whenever we go somewhere I can say, 'Come on, men!'" And he marched around the little bedroom stomping and swinging his arms in an exaggerated military march. "Come on, men, get in formation! March with me."

"Oh, Butch, we just can't have another baby," Carol sobbed. Butch marched out of the room. "Come on men, march with me!" He gathered up Rio and Marlon and Evan and made them march out the door and into the yard. "Troops, halt," he commanded, bringing his jostling, laughing troops to a bumbling stop at the front window so Carol could see them. "Major Butch and his troops reporting for duty ma'am," he said to Carol and saluted. "Ma'am, all I need is one more to fill out this platoon. Can you help me?"

Carol stopped crying and shook her head. She didn't really smile; she just stopped crying and shook her head.

"Oh, honey, late-in-life babies are the biggest blessing of all," Mrs. Brascomb replied when Carol told the little old ladies. The other three nodded.

"I had John Randolph eight years ago when I was forty-two, and he's been the biggest blessing in my life."

"Eight years ago," Carol thought. "My God, that would make her fifty. I thought she was seventy-five!"

"Well, I sure hope you're right, Mrs. Brascomb, 'cause with Butch and the three I already have, I feel like I've been blessed enough for a couple of lifetimes."

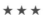

Carol had never known the sex of any her children until the day of delivery so when the sonogram technician asked her if she wanted to know, she hesitated. "Do you want to know, honey?" she asked Butch, who was in the examining room with her.

"You really know or you just guessing?" Butch inquired of the technician.

"No, I really know," she said. "Y'all want to know or not? It matters not to me."

"Well, yeah, then, we want to know, don't we, honey?" he said to Carol and the technician at the same time.

"OK, tell us," Carol said.

"Y'all are gonna be the proud parents of another . . ." she paused to heighten the suspense, "healthy baby girl."

"A girl," Butch said. "I'll be damn, a girl. Well, that's great, 'cause there's women at West Point now and the Naval Academy too. We'll have a female officer in charge of the platoon. He turned to Carol. "I haven't been thinking about girls' names. I was thinking about naming this one Brando if it was a boy. What are we going to call her?"

"Well, the ladies at school say a late-in-life baby is the biggest blessing, so let's call her Blessing."

"How about just Bless?" he said. "I think I like that better."

"She's your little girl. You name her whatever you want to, and Bless is fine with me."

"It's done then," he said "We're having a little girl named Bless."

"And bless us one and all," Carol said, "'cause that's it for this old mare. After this one I'm done. Finished. C'est tout and no more."

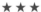

Bless was born in the hospital in Hammond, and she was Carol's easiest delivery. Bless was a happy newborn, smiling and alert. When the nurse brought her into Carol's hospital room for the first time, Butch blurted out, "Damn, she looks just like John Wayne."

"Butch," Carol scolded.

"I mean it, look at her! She looks just like John Wayne. Howdy, pardner," Butch said in his best John Wayne voice and lightly poked her belly with staccato fingertips.

So Bless joined the little troop in Jack, Louisiana. Butch would get up with Carol when she nursed her regardless of the time of night or how bad his back hurt. There wasn't much talking, just the three of them sitting together in the dark, with Carol nursing Bless, and Butch looking on. Now and then he would lean over and kiss the baby's head and say something. "Don't you love the way a baby's head smells honey? I just love that, don't you?"

Rio was still struggling in school, and their worry over him caused the only ripple in their otherwise tranquil lives. That, and an occasional late-

night tire in the ditch, but even those seemed to be getting further and further apart. Butch was gradually losing the stamina required for binges, and his back wasn't getting any better, even though he had cut back on the hard labor of ironworking or house painting as well.

Butch read a story in the *Picayune* about The Walker School in Mandeville, across Lake Pontchartrain from New Orleans, that specialized in children with learning disabilities. "Honey, we gotta check out this Walker place," he announced. "This might be the perfect place for Rio."

"But we'd have to move to Mandeville," she countered. "All the rich people from New Orleans are moving there. We'll never find a house we can afford, and we'll never find one as nice as Leota's with the yard and all."

"Yeah, but we've gotta get the boy some help. This looks like the perfect place for him."

Carol reluctantly went with Butch to have Rio evaluated at The Walker School. They tested him and diagnosed him with ADD, attention deficit disorder. The staff was very helpful, explaining to Carol and Butch that if Rio came to Walker, he would be prescribed Ritalin to help him concentrate, and they would structure a learning environment for him in which he could succeed. The school had a hefty endowment, and it accepted children with learning disabilities whether or not their parents had the means to pay tuition. If they could afford it, they paid; if they couldn't, it was subsidized. Carol reluctantly agreed that the opportunity was too good to pass up. Rio needed that kind of environment if he were ever going to acquire basic coping skills.

So they moved again. They were lucky enough to find a house to rent that was about a six-block walk from the lake. The house wasn't much, but it had a big side yard with giant loblolly pines in a grove that made a great spot for lawn chairs and a glider bench. They moved in on July 3, and on the Fourth of July they walked down to the lake and saw a huge fireworks show. It was a good omen, they agreed, a sign they'd made the right decision.

They started a new life, one more time, in Mandeville. Butch said, "Slim, we live in Mandy, and we're never gonna move again." He didn't realize how prophetic his words would be.

Bless was four years old. Most mornings she would stay home with Butch while Carol car-pooled the boys to school. Butch would make her breakfast, and they would sit at the kitchen table and plan their day. She would get assignments from Butch to clean up her room and make up her bed or gather up some art supplies and meet him in his little studio out in the backyard near the pine grove. Or he would read her the lead stories from the front page of the *Picayune*, avoiding the stories about murders or other crimes that had occurred in New Orleans the previous day or night. He spoke to her as if she were an adult, and whether she really understood or not didn't matter to Butch as much as the fact that she paid such close attention. She was a great help in the studio, too. She would hand him various found objects that he would apply to his latest collage or hold things while he glued them to a surface. Her small hands were ideal for reaching into tight spaces. She helped Butch squeeze old 45-rpm records, bottle caps, sign remnants, newspaper clippings, cast-off household appliance parts, and the random minutiae of other people's "junk" into busy, complicated art objects.

They were sitting at the table on a school day. Carol was on her car-pool duties. Butch was giving Bless a mock quiz on President Reagan.

"Where was President Reagan born?" he asked.

"Calforya," she replied.

"What did President Reagan do before he became president?"

"He was in a cowboy movie."

"What is his hobby?"

"Wood choppin' . . . I'm tired of this game, Daddy. Would you make me some scrambled eggs?"

Butch laughed, "Sure honey, I'm just teasing. You don't really have to answer any questions about President Reagan if you don't want to." He slid his chair back from the table and got up to walk over to the fridge to get the eggs. His hip bumped the corner of the table, and he lost his balance. He fell forward, pushing the table into Bless and knocking down a chair. He fell over the chair and onto the floor. Bless was frightened by the noise

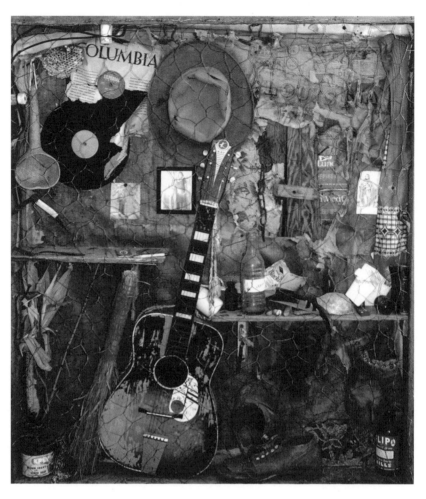

Record Bidness

as Butch struggled to keep his balance, grabbing at the table edge, before finally settling on the floor with the legs of the overturned chair pointing directly at his face. Bless sat in silence until she realized what had happened. She finally looked down at Butch on the floor bent awkwardly into an almost fetal position and said, "What happened, Daddy? Why are you down there?"

"I slipped, honey," he said, "and I think I hurt my back." The truth was that Butch had fallen because his back had just given out when he tried to stand. He thought he'd heard a funny grinding sound in the small of his back just before he fell. "Too many years of ironworkin', drinking, and carousing," he thought. "It's finally catching up with me."

"Get up, Daddy," Bless pleaded and walked over to crouch down near him.

"Pick that chair up, honey, and set it upright," he said. "I don't think I can move, and I don't want to look at all the gum your brothers have stuck under the bottom of this chair. I'm gonna choke those boys when they get back from school." Bless walked around and set the chair up. "Get up, Daddy. I want you to make me some scrambled eggs."

"I don't think I can, honey," he said. "Just sit with me here for a while 'til your momma comes home, and she'll help me get up and make your breakfast."

Butch couldn't move. It wasn't excruciating, just a dull, unfocused back pain that he had experienced before but never enough to immobilize him like this.

"Just come sit here with me for a while."

Bless sat on the floor next to Butch's face and stroked his forehead.

"Your head feels hot, Daddy," she said. They stayed on the floor together, with Bless gently patting her fallen hero's face and forehead, and Butch smiling through a grimace at his beautiful four-year-old daughter who reminded him of John Wayne.

"I got an idea, Daddy," she said. "Let's play a game. Where was President Reagan born?"

"I don't think I can play that game with you, honey. I don't feel so good right now. And anyway, you've already won it."

After what seemed like forever to Bless and just a few minutes to Butch, they heard Carol turn into the driveway and park the truck near the screened-in back porch. Bless got up and ran to the back porch. "Momma, come in quick! Daddy's on the floor and he won't get up."

Carol slammed the truck door closed and ran up the steps through the porch and into the kitchen. She saw the mess he had made when he crashed into the table, pushing the sugar bowl and salt and pepper shakers and the newspaper onto the floor. And Butch was on the floor, doubled over and obviously in pain.

"Honey, what happened?"

"I don't know what happened," he said. "I got up to make Blessie some eggs, and my back kinda gave out. I slammed into the table and the chair, and here we are. And I feel like I got a little fever or something."

"Well, that's it," she said. "We're gonna get your back looked at, and you're gonna have the surgery to fix it once and for all. I've had it with this back business, and I don't care what everybody says about back surgery, we're gonna get yours fixed. Can you move at all?"

"I don't think so," he said. "It's pretty painful."

"I'm calling the ambulance, and we're going to Ochsner right now and get your back fixed." Carol called 911. She called her daughters and asked them to pick up the boys from school, and then she called Butch's sister and Leota. In less than an hour they had all arrived, along with an Acadian Ambulance crew. After much discussion about the logistics of moving him and which position hurt and which position didn't, they got Butch loaded onto a gurney and into the back of the ambulance. The whole caravan made its way across the Lake Pontchartrain Causeway toward Ochsner Hospital in New Orleans. Carol was firmly in charge. She would ride with Butch in the ambulance, Erica and Ammye would follow with Marlon and Rio and Evan, and Bless would ride in the backseat of Aunt Linda's car with their grandmother. They blew through the tollbooth with sirens blaring and lights flashing. Speed limits were strictly enforced across the twenty-six-mile causeway because an accident could bottleneck the whole thing for hours. They crossed in under twenty minutes. Inside the ambulance, Carol sat on the floor next to Butch. "I bet you've never made it across

the causeway this fast, honey," she whispered to him. The paramedics had given him Valium and a muscle relaxant, and although he was still in pain, it seemed more manageable—or at least less important.

"You don't even want to know," he said, smiling as he recalled a wild, after-midnight crossing in a convertible in '68 or '69 with four or five other young men and women whose names he couldn't recall. "You don't even want to know."

It was a little after noon when they all pulled into the Ochsner emergency-room parking lot. The ambulance went directly to the emergency-room door under a covered semi-circle, and Linda and Erica parked. They all converged at the rear door of the ambulance as the paramedics carefully set up Butch's gurney.

Butch looked around and saw them all in various stages of concern and anxiety: his sister, his mother, his wife, his three boys, Bless, and Carol's two daughters, all trying to stake out some place to stand or try to figure out some way to help. He took comfort in them all being there, but it also bothered him that he had caused such a disruption. "Man, this is like Thanksgiving or something. We've got everybody here—it should be some kind of holiday."

It was starting to rain, and the paramedics grumbled about being hungry. It was past their lunchtime, and they wanted to get this done and get something to eat. They wheeled his gurney into the emergency room, got Butch transferred to a hospital bed behind a sheer screen in the admitting and processing area, rolled their equipment out through the sliding glass doors, and were gone.

Carol patiently waded through all the paperwork and insurance forms with a sullen young woman at the admitting desk, and it was three in the afternoon before an emergency-room doctor finally examined Butch. Carol was in the little screened-off examining area with Butch. Linda and Leota and Carol's girls and Bless were watching *Oprah* in the waiting room. The boys had found the candy and soda vending machines and were buzzing around the waiting room in a sugar-fueled game of tag under the disapproving glare of the admitting-desk nurse.

"Doctor, he needs back surgery," Carol said. She realized she didn't even

know the man's name. He hadn't introduced himself; he had just pushed back the screen, walked up to Butch's bedside, and begun taking his pulse and listening to his heart while a nurse assisting him took Butch's blood pressure and temperature.

"What happened?" the doctor asked. The question wasn't directed to Butch or to Carol. It was just a question, hanging in the air in the little examining area. "Is this a work-related injury?"

"I fell at home," Butch said.

"He collapsed in the kitchen," Carol said almost simultaneously. "He has a history of back problems, and he's been avoiding back surgery, but we think it's time for him to have it."

"We'll see," he said to Carol curtly, seeming slightly offended at her offering a diagnosis.

"Can you move?" he said to Butch.

"Not really," Butch replied.

"Well, you've got a little fever, but your vitals are OK, so we'll do some blood work, take some pictures of your back, and get you admitted. I'll have an orthopedist look at the X-rays of your back, and we'll see if we can figure out what's going on."

He turned to Carol. "This will take a while, and he's not critical, so if you want to go home, you can come back around seven tonight, and we should have a better feel for what we need to do here."

"I'd rather stay with him," she said.

"Suit yourself, but you won't be able to go with him into the radiology area, and we won't really know anything until we get his blood work and pictures back, so you might as well go home and come back tonight."

Carol reluctantly left Butch to go out to the waiting room to give a status report to the family and organize the rest of the afternoon and evening. Before leaving the hospital, she said to Butch, "It'll be okay, honey. We'll get your back fixed and it'll be okay." He nodded. "I'm gonna get everybody back home, and get the kids settled, and I'll be back around seven tonight." He acknowledged this with another nod and puckered his lips to make an air kiss. She walked back over to his bedside and bent down and kissed

him full on the mouth. "I love you," she said. "I'll see you in a little bit. It'll be okay." She turned and walked toward the waiting room. He didn't look good, she thought, and his mouth was hot.

Carol was self-conscious about the noise her shoes were making on the buffed tile floor of the hospital corridor. She didn't like hospitals, and it had been a long day. They had all driven back to Mandeville; Linda and Leota had gone back to Kentwood to await word from her on Butch's tests; and Ammye and Erica were staying with Bless and the boys tonight so she could be there with Butch overnight if she wanted to. It was a little after eight when she finally made it back to Ochsner. She didn't want to wake Butch if he was asleep, but she was anxious to find out the details of his tests. She nudged open the door to his room.

He had adjusted the head of the bed to an almost upright position, and he was sitting under a harsh fluorescent light reading the *Picayune*. The television suspended from a bracket on the ceiling was on, but the sound was down. "A lot of murders in this town," he said as he looked up at her and brought the paper down to his lap. "I've either got a bad infection or leukemia."

The two disconnected sentences shocked her. She felt frozen in place. "Say that again?" she blurted. "Say that again?"

"I said there's a lot of murders in this town."

"Not that, Butch," she interrupted him. "What did you say about leukemia?"

"They said I either have a really bad infection 'cause my white blood cell count is off the chart, or I've got leukemia."

Carol walked over to his bed and half-sat on his bedside. "We came here for back surgery. You don't have leukemia; you've got a bad back from too much heavy lifting. You just need to get your back fixed."

"Nope, it's not my back. My back's got some problems, but that's not what knocked me down today. There's either a bad infection or some kind of leukemia. That's what we're looking at."

Carol leaned forward and put her face between Butch's neck and shoulder. She couldn't think of anything to say. She didn't want to cry, but she could feel tears coming. She kept taking deep breaths, breathing in Butch's smell and feeling the deep strength in his neck and shoulder muscles from years of hard working and hard living. She tried to understand the impact of the words he'd just said—on him, on her, on the kids, and on everybody in their circle, small though it was.

He brought his right hand up and pressed the back of her head deeper into his neck. "It'll be OK, Slim. I'm ten feet tall and bullet-proof. Nothing can stop your old boy Butch."

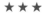

They were nervous in the oncology waiting room. Butch was reading a six-month-old *Time* magazine, and Carol was looking from patient to patient, shocked at how beat up they looked. Some had ink marks where radiation would be targeted; others were gaunt and bald from chemo. An older black man who had lost his hair was asleep, his cheek in his hand, propped up by his elbow on the plastic arm of an uncomfortable chair in a row of uncomfortable chairs bolted together. Butch had earlier engaged the man in an outrageous conversation, jokingly asking him if he wanted his hair to grow back straight or kinky. Butch talked to total strangers as though he had known them all his life. The old gentleman could have been offended or reacted angrily, but Butch's question had been so innocent and outrageous that the man had just laughed and answered, "I believe I'll try straight this time. Might as well—couldn't be no worse or better than the other way."

The door across the waiting room opened, and a nurse carrying a clipboard called out, "Mr. Hornsby?"

Butch and Carol got up, and the nurse escorted them down a short hallway to the office of Dr. Jack Saux, the oncologist in Mandeville who was on the ironworker's union list of preferred providers.

He stood up and motioned for Butch and Carol to sit in the two chairs facing his desk. "Well, you do have leukemia, Mr. Hornsby, and it looks to be a pretty potent version of it, based on your blood counts. We call it

chronic lymphocytic leukemia. But it's not all bad news. The five-year survival rate is over 75 percent, and a man of your age and in your overall physical condition could live ten to fifteen years with this and not suffer many ill effects. In fact, I'm thinking that at least for now, I'm not going to treat this with anything but some pain medication that you can take from time to time as necessary. I don't think chemo or any aggressive treatment is called for at this time."

They listened and thought about what he said. They simultaneously realized that this was a major turning point in Butch's life. He was on the downward side of the mountain.

Butch had never even considered mortality. Maybe when they were caught up in the Swaggart thing it might have crossed his mind, especially when Swaggart preached about heaven and hell, but that was just preaching—it wasn't about him, or them. Carol had never known Butch as anything but a vigorous, energetic man, sometimes too energetic. Her permanent mental image of him was of him swinging crazily around the sign pole on Chimes Street when they were twenty-somethings. It played like a little movie loop in her head. He couldn't have a limited life expectancy, not Butch—he just couldn't.

"Ten to fifteen years doesn't sound long enough to me, Doc," Butch said. "Could I get you to up it to twenty to twenty-five years?"

Doctor Saux looked directly at Carol. "Well, I just want to be forthcoming and honest with you both." Turning back to Butch, he said: "You could live longer, but I think it's more reasonable to honestly deal with the time parameters I've given you. I think you'll both be better for knowing what the realistic expectations are so you can plan your lives accordingly. Your body is producing too many white blood cells, so you'll have to be careful about cuts or bruises and infections like cold or flu, but even with those limitations you can lead a relatively normal life."

"You said you didn't want to treat him with chemo or anything. Would it make any difference if you did treat him more aggressively?" Carol asked.

"I don't think so. I could, but it would diminish his quality of life considerably and probably wouldn't prolong it much, if at all. If he has bouts of elevated white cells that cause the kind of debilitating symptoms that sent

him to the hospital, I'd probably treat him with a steroid infusion to calm that down, but it might not happen again."

They looked at each other for a long time without saying anything. Carol reached over to hold Butch's hand.

"How do you think he got this?" Carol asked.

"We don't really know how it develops, and the hematologists don't really know either. There could be some environmental factors, like working around welding and steel or a genetic predisposition, or it could even possibly have a viral origin, but we really don't have a scientific answer to how or why it develops, or a silver bullet to cure it."

"Wow," Butch said, "I'm gonna die. I never thought I'd hear myself say that."

Carol turned to him, "Well, don't say it, then. You're not going to die. You're going to live for as long as you live, and we'll have a great time watching Bless and the boys grow up. You can paint and make your art and write songs and I'll cook and we'll walk to the lake and have a ball. In the afternoons we'll sit under the pines and read and shoot the bull, and we'll have the same great life that we've always had."

"Do you have any other questions, or is there anything else you want to talk to me about?" Dr. Saux asked. "If not, stop at the reception desk and make a follow-up appointment for about six months from now, and we'll have appointments at regular six-month intervals."

They walked out of his office, made the appointment, walked out to the parking lot, and got into Butch's truck. Carol was driving. Butch was slumped against the passenger door. He looked tired and beaten down.

"I swear to God, Carol, you can look at a field of shit and see a flower. We're broke as hell, I don't have life insurance or a job and I couldn't work if I wanted to, I've been a piss-poor provider, we don't even own our house, I've totally screwed up every chance I had to make something happen, and you sit in there singing about some kind of idyllic life under the goddamn pine trees to some stranger who just told us I'm about to die." He looked at her and shook his head and shrugged his shoulders incredulously.

"Feeling sorry for yourself, honey?" she asked. "Well, then, when we get home you just go and march those men of yours around the yard. Be-

cause we can either do that and slow down and enjoy every minute we've got left and make ten years into a hundred, or we can cry and moan and whine about how horrible and unfair everything is.

"It's your choice, but I'm going to stay as positive as I can. And I'm going to try as hard as I can to make us aware of and thankful for every second we have left. We're going to wring every speck of enjoyment we can out of every one of those seconds."

"I guess," he said.

And so began the last and most complicated phase of their lives together. There were two conflicting dynamics at work. The kids were on the upward phase, and, in a sense, so was Carol. They were growing and learning, pushing boundaries and experimenting, getting into scrapes and working through serial identities, especially the boys—buzz cuts and Doc Martens one year, ponytails and weed the next. Carol started working as a chef, first in a small Cajun café in Mandeville, then at a larger, more challenging Mexican restaurant in Hammond, about thirty miles away. She had much more responsibility at the new job, and it took up more of her time and attention. Butch was always her first priority, but she loved cooking and the feeling of independence that working and making money gave her. Butch wanted her to work and be independent. He missed her sometimes when she'd work late, but he and Bless would talk and laugh and watch TV and pass the time waiting for her to come home.

Butch was in the accelerating downward arc of his life. He'd have bouts of elevated white blood cells or minor infections that turned into crises, but he maintained his sense of humor and the ability to laugh at himself and his condition. There were numerous late-night emergency-room visits, each requiring a gathering of kids and siblings and Leota and nieces and nephews, all on a solemn death watch at the hospital until they were dismissed the next morning when Butch woke up strong as a mule, demanding to be taken home. There were bursts of enormous creative energy when Butch would produce incredible collages and bizarre constructions of screen doors in the shape of Huddie Ledbetter or telephone-pole posters in the chitlin'-circuit style announcing a performance by Brownie Terry and Sonny McGee at the Dew Drop Inn in Bogalusa. He would call

Duke and convince him to ride his motorcycle over from Destin for a visit. Butch liked the acoustics in the hall bathroom, so he and Duke would cram themselves in there in a complicated male choreography that required no touching, and he'd play Duke new songs he had written and get him to critique them and sing harmony on the choruses. He had a steady stream of visitors and a small army of people who wanted to do things for him. Johnny drove from Baton Rouge regularly to check on him and help him with little errands and repair jobs around the house that were getting harder and harder for him to do.

Leota died. It was on a Tuesday. They drove to her wake at the McKneely Funeral Home in Amite on Thursday night, and her funeral was Friday morning at the Arcola First Baptist Church. She was buried beside Lester in the little overgrown cemetery in Pine Grove. Leota had left her children a little money and the homestead, which Butch and his brother and sister sold. They gave Butch half of the sale money and split the other half.

Between what Carol was making as a chef and the money that his mother had left him, they enjoyed a period of relative financial security, probably for the first time ever.

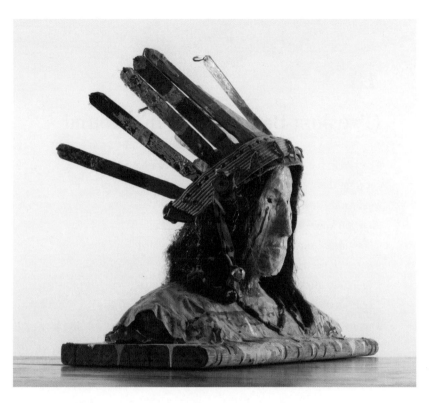

The Chief

13

(I've Just Been) Knockin' Around

I can go into every club in town, and not get what I need,
Sit right there and drown, sit right there and bleed,
Yeah, and I've been drunk amongst you all,
And you know me for some jive,
Sometimes I slip so far down, I don't even realize
That in the end it's the money that matters,
I've looked all my life and I've found,
I've been dissatisfied for a long time now,
I've just been knockin' around . . .

CAROL SPENT A FITFUL AND RESTLESS NIGHT. Her nights mirrored Butch's, so when his were fitful and restless, hers were too. This night had been particularly long, and when the little red digital numbers on the bedside clock finally said 5:00 a.m., Carol was ready to get up. Butch had been awake almost all night, maintaining a steady, low moan. It upset her that there was nothing she could do. His pain was big and growing. It had broken through most of his pain medicine and even the fentanyl patch had stopped working. He was down to under one hundred pounds and had big sores from being immobile in bed, and scars where he had jacks for different infusions—chemo, pain medication, antibiotics, and whatever else Dr. Saux could throw at leukemia. Several times during the night he had turned to Carol and whispered, "I love you, honey. Thank you." Each time she turned back to him and said, "I love you too, baby, and you don't thank me for anything. I should be thanking you."

She stumbled out of bed in the dark and made her way by feel into the small kitchen to make Butch an old-fashioned drip pot of dark-roast coffee

and chicory. She had tried to get him to sample others, but he only wanted dark-roast coffee and chicory. "That's good old South Louisiana coffee," he would say. "Why try anything else?" Eventually, she agreed. Why, indeed, try anything else? Butch was a traditionalist. He loved familiar objects. He had even insisted that Carol find an old fifties-style oilcloth table cover for the small dinette in the kitchen. He said it reminded him of his momma's kitchen table and growing up in the country.

The pattern of their days had become familiar too. She would get up, make Butch his coffee, and take it to him in bed. They would talk for an hour or two, depending on what time he woke up, and then one of the boys, Marlon, Rio, or Evan, would pick him up and put him in a soft chair. He would watch a little television, Judge Judy or Jimmy Swaggart, and then he'd have to be put back in bed. Before he became feeble and emaciated, he would rant at the daytime talk shows—Maury, Jerry Springer—the fight shows, he called them. "They trot out the worst of unwed mothers, transgenders, paternity-denyin' ghetto-talkin' trailer trash from all over the United goddamn States. And the idiots who watch them think they're look-ing at TV stars and want to be like them. Can you believe this?" he'd say to nobody in particular but expecting a response from Carol.

"No, I can't, honey," she'd say to him in as soothing a voice as she could. "I really can't."

Carol finished dripping the coffee, poured a small cup for Butch with plenty of cream and sugar, and walked it to his bedside. She placed it on the bedside table and crawled under the covers with him. It still shocked her to see how he had wasted away. This big, strong, vinegar-filled, rowdy ironworker and badass country singer had become a tiny, shriveled, an-gular mess of skin and bones. She placed her arm under his neck to hold his head up, and her upper arm was bigger than his neck. "I brought your coffee, baby," she whispered. Butch opened his eyes with much effort and looked at Carol. "I love you, honey. Thank you."

"Stop saying that. Butch," she said. "We've already been over that."

"No, I mean it, and I don't think I can drink my coffee." He wheezed and coughed a little and shuddered. "Go get Blessie."

"What's wrong, baby? You have a bad night?"

"Carol, I think it's time," he whispered. He wheezed again. "Go get Blessie."

"Butch, don't say that. We'll have a great day today and we'll watch Judge Judy."

"I don't think so, Carol. Please go get my baby girl."

Carol carefully withdrew her arm from under his head. His breathing was becoming more labored. She walked to Bless's bedroom door and slowly opened it. Bless was asleep and peaceful. She looked just like Butch. "Blessie," Carol whispered and walked over to her bedside. "Bless," she said again and gave her a slight nudge. "Bless, wake up. Your daddy wants to talk to you."

"What's wrong, Momma? Is something wrong?"

"He just wants to talk to you, honey."

Bless got out of bed and followed Carol down the little darkened hall. She had on one of Butch's old T-shirts.

They walked into Butch and Carol's bedroom, and Bless gasped and caught her breath.

"What's wrong, Daddy? You don't feel good this morning?" she said and crawled into bed on Carol's side. Carol got under the covers on Butch's side. They both kissed his cheeks and neck. His breathing was labored and getting harder. "Carol," he whispered, "without you and Bless and the boys"—he stopped to catch his breath—"my whole life is pretty much woulda, coulda, shoulda."

"Don't say that, Butch,"

"Don't say that, Daddy." Carol and Bless spoke in almost perfect unison.

"No, it's true," Butch coughed, "and I want you to know how much I really love you both and appreciate all you've done for me.

"Stop it, Daddy, you're upsetting me; stop it." Bless looked at Butch and then at Carol and then back to Butch, holding their eyes for as long as she could.

She looked back at Carol. "Momma, is this it?"

"I don't know, honey," Carol said, trying vainly not to sob.

"Daddy, don't die now. Wait 'til tomorrow. I want to show you something from school this afternoon." The room was quiet with only the sound

of Butch's labored breathing. He managed a slight laugh. Then, with all the energy he could summon, he inhaled a full lung of air, held it for a moment, and then let it all out, making a slight blowing noise as he did. He closed his eyes and never breathed again. It was a good death.

Bless and Carol lay on either side of him, sobbing and shaking.

"He's dead, Momma," Bless whispered. "I think he's dead."

"He is, baby. He's finally got some peace. Go get your brothers."

"I can't, Momma. I can't move. I'm sorry. You have to go get them."

A few minutes passed while Carol and Bless lay at Butch's side. Carol finally got up and made the rounds of the boys' rooms to wake them up. She shook each one and said the same thing. "Evan, come to our bedroom . . . Marlon, come to our bedroom . . . Rio, come to our bedroom," and went to get back in bed with Bless and Butch. One by one, the boys made their way into the bedroom. It was obvious that Butch was dead. None of them was surprised. They had been a lot more certain it would happen than either Bless or Carol. The three of them stood at the foot of the bed. They each had their hands on the footboard. "Daddy's dead," Bless cried; "he's dead."

Carol got up and turned to the boys. "Kiss your daddy good-bye, boys. For the first time in a long time he's not in any pain."

One by one, each of Butch's sons came to his side and leaned over and kissed him. Marlon and Rio kissed him on the forehead; Evan kissed him on the cheek. They each took turns holding his shriveled left hand. Carol leaned down to pull the sheet up over Butch's face.

"What are you doing, Momma?" Bless cried. "Don't do that! Don't cover up his face."

"I'm sorry, honey. I was just trying to respect the dead. I won't cover him if you don't want me to."

Rio turned first and walked out. He walked onto the little screen porch and through the screen door that Butch had made with the image of some bluesman cut out of tin. He had even put strings on the guitar the bluesman held in his hands. He had meticulously cut out the outlines of a porkpie hat and the obligatory dangling cigarette. "Probably Robert Johnson," Butch had mused at the time, "but maybe Leadbelly." Rio slammed the screen door so hard the guitar strings rattled out a strange, dissonant mu-

sical note. He stood in the first light of that morning and looked up at the tips of the tall pine trees that took up most of the space on his parents' lot. He looked over at the little studio where Butch created intricate, soulful collages with things other people didn't want. Old records, beer-bottle caps, matchbooks, advertising signs, anything he could find. Rio looked at the little sitting area with a swing where Butch and Carol had spent most of their afternoons when Butch was better. He put his face into his hands. After a few moments he put his hands on his hips, bent backward at the waist, and broke the silence of the Mandeville morning with a full-throated and loud . . . "Goddammmitt!"

Marlon followed out shortly after Rio. But he went back to his room, booted up his computer, and joined a nonstop, multiplayer game-in-progress called Imperial Death Star. He could do it for hours. And he could join in at any time.

Evan stayed in the bedroom with Bless and Carol. He walked over and sat in Butch's chair. He tried as hard as he could not to cry. Butch had prepared him. He knew he'd have to help his Mom with the funeral-home calls, and the relative calls, and the friend calls, and the obituary. All that stuff, and he was ready. He leaned back over his shoulder and asked Carol, "Mom, you think he wants to watch Judge Judy?"

"He probably does, honey . . . knowing your Daddy."

Butch didn't want a funeral. He had told Carol this many times over the past few years—no funeral and no casket.

"Don't waste money on embalming fluid," he would say. "I've got enough gin in my system already. Puttin' embalming fluid in me would be like bringing a beer to the Jack Daniels distillery. Just burn me up and put my ashes in a kitchen matchbox. That's all the funeral I need."

Ammye and Erica took charge of everything. They got the boys' coats and pants out and organized, they bought them new ties and new white dress shirts, and they fitted Bless in a black dress Ammye had worn to her grandmother's funeral. They got Butch's clothes together and made all the

arrangements with the funeral home. Carol's only job was to comfort and be comforted by her children.

There was a small wake, just like Leota's, at the McKneely Funeral Home in Amite. Carol was distraught when the funeral director told her that state law required that Butch be embalmed even if he was going to be cremated. "It's a good thing Butch isn't around to hear that," she thought; "it would have sent him into orbit." She could imagine his tirade: "The damn funeral industry lobby got the damn state legislature to pass a law requiring embalming just so they could charge the family for the embalming fluid. Those sons a' bitches in Baton Rouge will do anything for a steak dinner. Good thing Uncle Earl's not around—he'd run 'em all outta' town on a rail." But his body was embalmed and then cremated, and they took his ashes in a clay jar to the Harvest Church in Hammond for a Christian burial service. They'd been going to Harvest Church for a few years, and Carol and Evan especially had been active there. Evan sang in the choir and was the youth prayer leader, and Carol helped the preacher and his wife in the ministry. Butch liked the church, although the Swaggart experience had drained some of his fervor.

When the service was over, they didn't really know what to do with Butch's ashes, so Carol gathered up the clay jar and took it home. The jar sat conspicuously on the kitchen table for a couple of days until Ammye and Erica decided to wrap the jar in a couple of Butch's bandanas and organize a proper burial. Just as they had taken charge of the funeral arrangements, they took charge of the burial. Butch wasn't their father, but he had endeared himself to them in so many ways that he was like a father and much more. He was a friend they could talk to about cheerleading problems and boyfriend troubles. He counseled them on drinking and sororities,and told them he would beat them with a mule whip if they ever got a tattoo. He was more soul mate than stepfather. Butch had nicknamed them Olga and Helga so long ago that they couldn't remember who was Olga and who was Helga, but they remembered that Butch had brought them and their mother into his life and his heart and made them all a family. Blood or not, they were family.

So the girls got everybody together and organized a meeting at the Pine

Grove Cemetery for a proper burial. Butch's sister was in the last of the four cars to drive up to the cemetery. It was almost two in the afternoon, and it was hot. There were no trees, no way to escape the direct blast of the sun. Carol and her girls and Bless stood on one side of Leota's headstone, and Butch's sister and two of his nieces stood on the other. Rio, Marlon, and Evan took turns digging in the dry, brittle dirt. Evan made sure that the overgrown sod they dug up was protected so that it could be replaced. They dug a small circular hole about a foot deep. Carol bent down and placed the clay jar wrapped in red and blue bandanas into the hole.

"Mom, you want to say something before we cover him up?" Evan asked.

Carol thought for a minute, smiled slightly, and looked around at the little burial party.

"I'm not sure, y'all, but I think what we're doing is against the law. I don't think you're supposed to just go bury somebody without some official notification or something, but I'm sure this is the way your Dad would have wanted it. God bless you, Butch. We all love and miss you."

Rio and Marlon shoveled dirt over the jar and patted the earth smooth with the flat side of the shovel blade. Evan carefully put back the sod and stomped down on it, working it back into place. No one walking by Butch's burial place later that day would have even noticed that the grass had been disturbed. For someone who cut a wide swath in his life, he left the world quietly, tended by those he loved most. For as large a footprint as Butch left in life, he would tread almost imperceptibly in death.

Epilogue

Oh, Maya, don't go back to Sweden,
I ain't lyin' to ya, you what I been needin'

(fragment Butch sang to a Delta Airlines flight attendant from Sweden)

BUTCH'S FUNERAL AND BURIAL HAD BEEN a private, mostly family af-
fair. Few of his friends or fans had been there, so in November 2004, al-
most a year after his death, Johnny and Carol organized a celebration of
Butch's music and life at Johnny's recording studio on Main Street in Baton
Rouge. Carol brought some pieces of Butch's art and some photos of Butch
and hung the collages and taped the photos around the walls of the studio.
A riser had been brought in to serve as a makeshift stage, and there were
mikes and instruments on the riser. There would be stories about Butch
and performances of his music. Johnny and Carol wanted a roast, not a
solemn memorial.

Duke came from Destin, and Casey Kelly came from Nashville. The
two performed a version of "Dirtdobber Blues" preceded by a verbal riff
by Duke that was periodically interrupted by laughter. He explained that
Butch had written the song from the point of view of a dirtdobber, and
that the chorus contained the line, "commence dobbing, past fingers and
thumbs."

Bonnie came from Los Angeles and, with Merle Brigante from Aus-
tin on drums, gave a rousing account of "Rock Bottom on Romaine" and
fondly recalled her time with Butch and Johnny and Duke and other Loui-
sianans in L.A. in the sixties.

Johnny was the MC, inviting friends and fans from the audience to the mike to share their version of Butch's escapades. He called up John Fred, who was suffering with kidney disease and undergoing dialysis, but who nevertheless found the strength to relate this story.

"I first met Butch when I was playing basketball for Southeastern Louisiana College in Hammond. I played a little music on the weekends, and Butch would always hang around the bandstand. One night after a gig he came up to me and introduced himself. I forgot what name he used. It may have been Butch, but it could have been Swan, or Led Smutch, or Abe Youcats, or any of about eight names he called himself. Anyway, he introduced himself and said he wanted to sing with the band. I asked him if he had ever sung with a band before, and he said something like, 'Hell, yeah, old son . . . I just got back from touring with Eric Burdon and the Animals. Hell, yeah, I can sing.'

"And you all know Butch had never sung with a band before, but he was so convincing I believed him. The next week we were playing at a place called the Cave Tangi in Hammond. Butch was there, and he kept bugging me to let him sing. I finally gave in, and he got up onstage and proceeded to sing "House of the Rising Sun." He slaughtered it. His time was terrible, he was singing it in the wrong key, and it was just a mess. I finally had to take the mike from him and finish it myself. When the song ended, I was kinda pissed. I turned the mike off and said something like, 'Man, I thought you said you could sing.' Without missing a beat, he shot back, 'I can sing; y'all just can't play.' You really couldn't stay mad at Butch for long because of outrageous comebacks like that. So I told him that next week he could come to the gig. He couldn't sing, but he could take up the door.

"In those days, we would just play for whatever we collected at the door from people paying admission. So next week Butch was part of the band, collecting at the door. The Cave Tangi held about two hundred people, and I think the cover charge was a dollar, but it wasn't much. I figured there were about a hundred people at the gig that night so I thought we'd make about a hundred dollars, which would have been about twenty bucks a man—pretty good for 1964. Butch would collect the money, stamp the people with a rubber stamp, aggravate some of them by doing stuff like

saying that they had to recite the Pledge of Allegiance to get in, and put the money in a cigar box that he had wrapped one of those damn bandanas around. We played from nine to one, and when we quit I walked up to the front door to get an accounting from Butch and collect and distribute the money. I counted up about forty or forty-five dollars, and I asked Butch what happed to the rest. With a completely straight face, he said: 'I spent some of it on beer for me and some buddies, and I let the pretty girls in free. Hell, I'm with the band now—I get a cut don't I? But don't worry, man, I'll pay it back.' Well. after that, everywhere I went people would come up to me and say, 'Hey, John Fred, where's Butch?'"

Johnny then called up one of Butch's boyhood friends from Amite. He told of lost weekends with Butch when Butch and three or four teenage buddies would drink and stay up all weekend, fueled by Butch's manic energy. On one occasion, Butch had them stop at a farmer's fruit stand on the highway near Kentwood. Butch's instructions were very precise: they were to buy three big watermelons and a cantaloupe. Then they drove to Baton Rouge and parked the car at the base of the levee near the LSU Veterinary School. Butch took them all behind the levee to the grassy batture. By the light of a full summer moon, he carefully cut the watermelons in half and handed a half to each of his friends. Then he took his watermelon half and put it on his head, seeds and juice dripping down his face and the front and back of his shirt. He did the same to each of the other boys and then split them into teams. "All right, men," he said, "we're the LSU Tigers, and y'all are Ole Miss," and with the cantaloupe for a ball they played a slap-dash game of tackle football.

Johnny looked to the left of the riser and asked, "Are you ready?"

"Yeah, sure, I guess," came the reply.

"This next person has been around the block a few times with Butch," Johnny said. "In fact, when Casey was married to Julie Didier and they lived in New York, I think Butch lived with them for a while. Please welcome . . . Casey Kelly."

Casey walked up to the mike and in his shy, self-effacing manner said, "Actually Butch lived with me at some point pretty much everywhere I ever lived." He lowered the microphone with the casual ease of someone

who's done it for a long time. "Every single place I lived, eventually I'd run into Butch. And the story I'm going to share is a lot like John Fred's, more of the same. I do want to take a minute, though, to say how amazing and magical it was being around Butch—being around his creativity, his frustration with life sometimes. And he broke all our hearts at one time or another. At one time or another everybody was just so outdone with him— there were nothing but extremes with him, and that's probably why we're all here today. People like Butch put some texture into life. Sometimes it was unpleasant texture, but that's better than no texture at all.

"I guess it must have been sometime in the early eighties when Butch and Carol moved to Nashville. Butch wanted to do the Nashville scene, and he had a deal with James Stroud, who went on to become a very successful producer. That didn't work out exactly, but that's another story.

"I was doing a showcase at the Bluebird Café on Hillsboro Road, and I asked Butch to take up the door." There was a combination of laughter and audible groans from the audience. "He told me that he had quit drinking, and I was so proud of him. I thought that collecting at the door would give him an opportunity for him to meet some Nashville cats and make some contacts. He could make friends easier and faster than anyone I've ever known. So sure enough, Butch was collecting at the door, and during the course of my set, I noticed that he would wander around the club and go back and forth to the bar, and, just like with John Fred's experience, at the end of the gig Butch had 'skimmed' a sizable portion of the receipts and was pretty much bombed.

"Just a few weeks earlier the Nashville City Council had really cracked down on DWIs, and they had put in a mandatory forty-eight-hour jail stay for people caught drinking and driving. And the Nashville cops hung out around the Bluebird waiting to catch musicians. So I told Butch that I would drive him home, and we loaded my stuff into my van and drove toward Vanderbilt, where Butch and Carol lived on one side of a little duplex. As I put my turn signal on to drop Butch off, he said to me in a very anxious tone, 'You're not going home already are you?' It was almost 2:00 a.m., and I told him I was. He said, 'Well, at least let's go to the iHop and get something to eat.'

132

"So we went to the iHop near Vanderbilt and sat in a booth. And just coincidentally, this was where off-duty cops hung out, so there were cops everywhere. We had this pretty, petite black waitress who gave us menus, and of course Butch was instantly determined to engage with her. We were having some ridiculous philosophical conversation about the items on the iHop menu when she came back with water glasses. Butch grabbed her wrist as she put the glasses on the table. She freaked, and I looked around at all the cops and I freaked. Butch said to her, 'You act like you don't recognize me.' She regained her composure and said something back to him like, 'No, I don't recognize you—should I? Who are you?' And Butch said very softly, 'Well, Richard Penniman of course,' and he leaped up and sang out in full voice 'Jenny, Jenny, Jenny, won't you come along with me, Jenny, Jenny, woo Jenny, Jenny,' sounding just like Little Richard. Then he just sat back down and we had coffee and I took him home. And as I said, we all loved Butch, and the things that he did were just beyond comprehension. You never knew what was coming next."

Johnny came back up on the riser. "Anybody else want to share a Butch story?" There was a little stirring in the crowd. "Well, while y'all are working up the nerve I'm going to read you a letter from Casey's ex, Julie Didier. Butch lived with Casey and Julie in Greenwich Village in 1964."

Johnny read her letter in which she described the time in Butch's life that he decided that he was going to be a fashion model. "Why not?" Johnny said looking up from the letter, "I don't think it would have surprised any of us if Butch had announced one day that he was going to be a brain surgeon or that he was going to run for president of France." He looked out over the audience, "Anybody else?" A few of Butch's friends from outside music and ironworking shared similar stories of Butch's unpredictability and gave further proof of how Butch got people to follow in his wake, swept along by a combination of shock and laughter, surprise and outrage.

Finally, Johnny called Carol up to the riser, and she brought Bless and Rio and Marlon and Evan and Erica and Ammye with her. She introduced them all, touching them on the face or chest as she did, and she got heckled by the audience when she forgot to introduce Bless. "Thank y'all so

much for coming here today and showing us how much you, like us, loved Butch and loved being around him. My most overwhelming feeling right now as I look out at all of you— some of you I know little, some of you I know well, to paraphrase Butch—is that I wouldn't have known any of you without having known Butch. I can't even count the number of people I've met because of Butch. He had first-name relationships with every mailman everywhere we ever lived, and it went on and on like that because he loved people and people loved him back, even if he made it hard sometimes.

"And I'm sure you all know that at the end he didn't want to see anybody, not because he didn't want to see anybody, but because he just didn't want anybody to see him. He wanted you to remember him as the funny, full-of-life character that he was and not as a feeble, dying man.

"And like you, I have a million stories I could tell about Butch, but these kids are my best Butch story, and of all the things he did in his life, these kids, our family, is the best thing that he did. I've talked too much. I love you all, and thanks for being with us today."

"Thanks, everybody," Johnny said. "We've had a great time sharing Butch's stories and music today. Stay as long as you want, but thanks again for coming." He started off the riser, then walked back to the mike and looked directly at where Tut and I were standing near the back of the crowd. "Cy, we haven't heard from you today. You sure you don't want to say something?" Most of the people turned to look.

"I don't believe, John. Thanks, though. Maybe one day I'll write something about him."

Bless

A NOTE TO THE READER: Thank you for your commitment of time and attention to Butch's story. I observed first hand through my mother how destructive and damaging alcoholism can be. Like Butch, she overcame her alcoholism and, through a supreme act of will, lived almost fifty sober and happy years. So I brought a personal weight to the telling of Butch's story. I loved him and I loved his music and his art. I wish he were still alive. I wish he had enjoyed some commercial success in his lifetime. He's not and he didn't, but he left a legacy of laughter, poignant poetic music, crazy funny art, and occasionally frustration to the people whose lives he touched. That is the arc of human life and the definition of the spirit.

Thanks again, and I welcome your feedback and input at cevetter@mac .com. I will also be available for phone or video conference calls or personal visits with book clubs, booksellers, reviewers—in short, anyone interested in the unique but in some ways prototypically American life of Butch Hornsby.

Sheet Music

Believer in the Blues

Words and Music by
Butch Hornsby

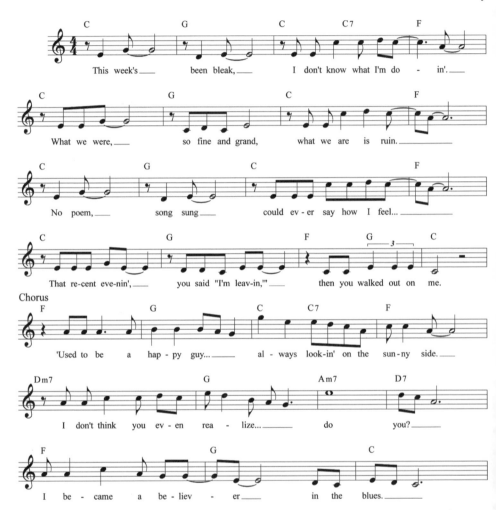

Believer in the Blues

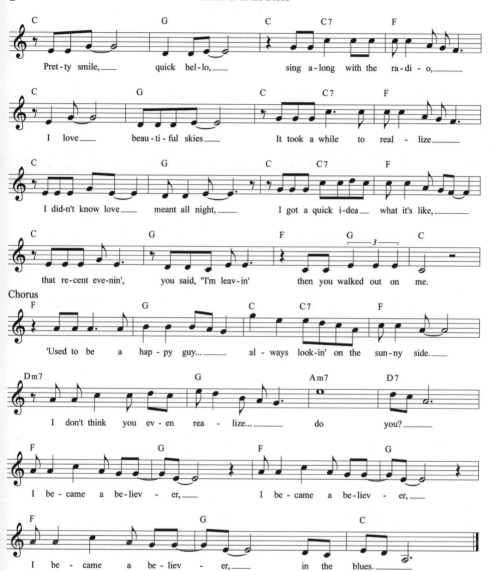

Pret-ty smile,___ quick hel-lo,___ sing a-long with the ra-di-o,___

I love___ beau-ti-ful skies___ It took a while to real - lize___

I did-n't know love___ meant all night,___ I got a quick i-dea___ what it's like,___

that re-cent eve-nin', you said, "I'm leav-in' then you walked out on me.

Chorus

'Used to be a hap-py guy...___ al - ways look-in' on the sun-ny side.___

I don't think you ev - en rea - lize...___ do you?___

I be - came a be-liev - er,___ I be - came a be-liev - er,___

I be - came a be-liev - er,___ in the blues.___

My Little Artist

Words and Music by
Butch Hornsby

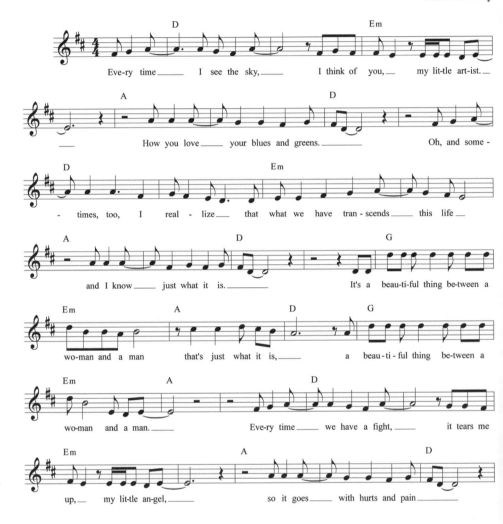

My Little Artist

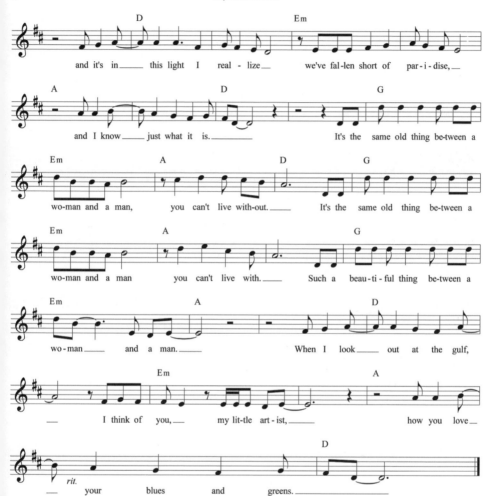

and it's in____ this light I real - lize___ we've fal-len short of par - i - dise, ___

and I know____ just what it is._____ It's the same old thing be-tween a

wo-man and a man, you can't live with-out.____ It's the same old thing be-tween a

wo-man and a man you can't live with.____ Such a beau-ti-ful thing be-tween a

wo - man____ and a man.____ When I look____ out at the gulf,

___ I think of you, ___ my lit-tle art - ist, _____ how you love___

rit.

___ your blues and greens._____

L.A., Oh No!

Words and Music by
Butch Hornsby

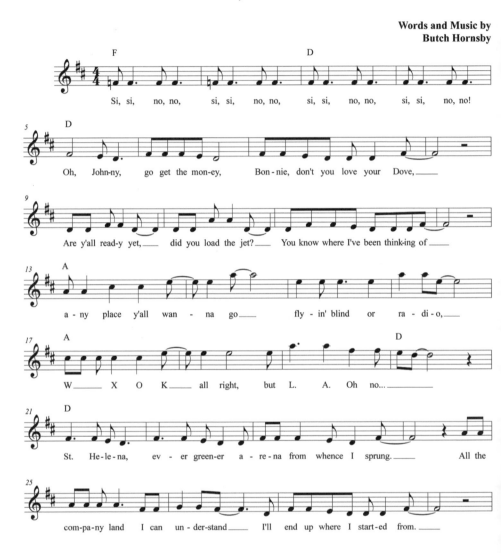

L.A., Oh No!

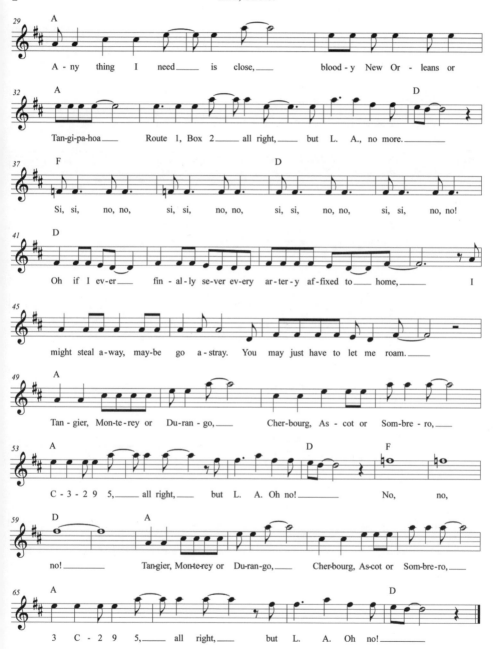

A - ny thing I need___ is close,___ blood - y New Or - leans or Tan-gi-pa-hoa___ Route 1, Box 2___ all right,___ but L. A., no more.___

Si, si, no, no, si, si, no, no, si, si, no, no, si, si, no, no!

Oh if I ev-er___ fin - al-ly se-ver ev-ery ar-ter-y af-fixed to___ home,___ I might steal a-way, may-be go a-stray. You may just have to let me roam.___

Tan - gier, Mon-te-rey or Du-ran-go,___ Cher-bourg, As - cot or Som-bre - ro,___ C - 3 - 2 9 5,___ all right,___ but L. A. Oh no!___ No, no,

no!___ Tan-gier, Mon-te-rey or Du-ran-go,___ Cher-bourg, As-cot or Som-bre-ro,___ 3 C - 2 9 5,___ all right,___ but L. A. Oh no!___

Rock Bottom on Romaine (St.)

Words and Music by
Butch Hornsby

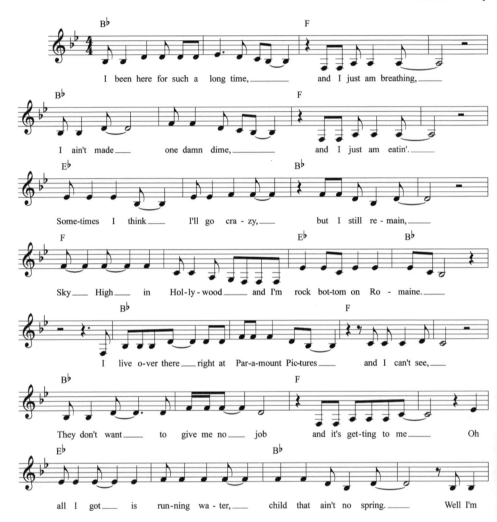

Rock Bottom on Romaine (St.)

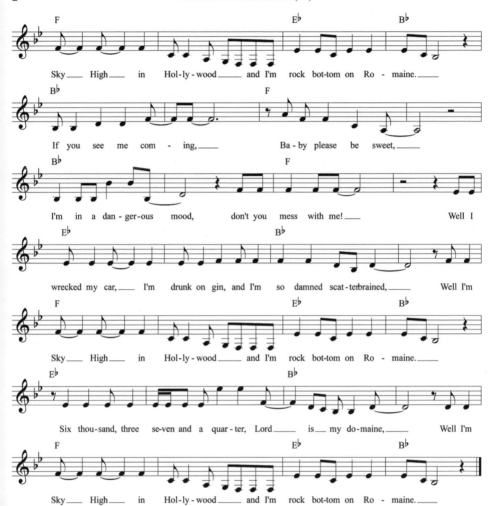

Sky___ High___ in Hol-ly-wood___ and I'm rock bot-tom on Ro - maine.___

If you see me com - ing, ___ Ba - by please be sweet,___

I'm in a dan-ger-ous mood, don't you mess with me!___ Well I

wrecked my car,___ I'm drunk on gin, and I'm so damned scat-terbrained,___ Well I'm

Sky___ High___ in Hol-ly-wood___ and I'm rock bot-tom on Ro - maine.___

Six thou-sand, three se-ven and a quar-ter, Lord___ is__ my do-maine,___ Well I'm

Sky___ High___ in Hol-ly-wood___ and I'm rock bot-tom on Ro - maine.___

I Ain't No Chauffeur
(But I Can Hold It in the Road)

Words and Music by
Butch Hornsby

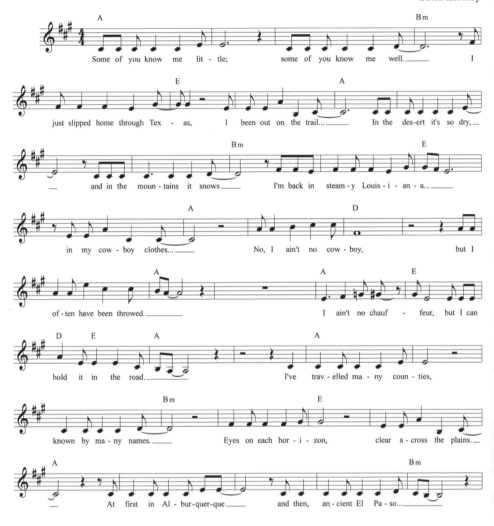

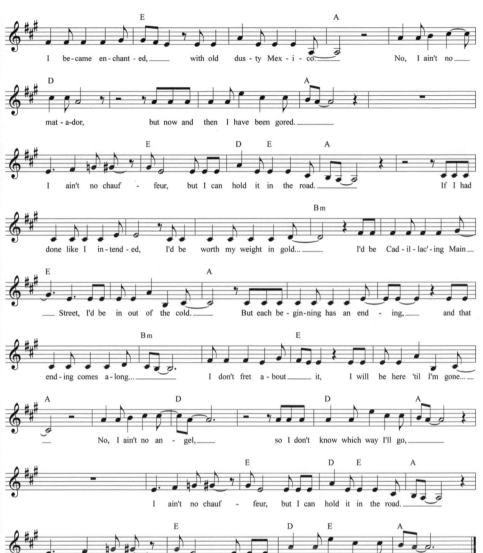

I Miss Y'all

Words and Music by
Butch Hornsby

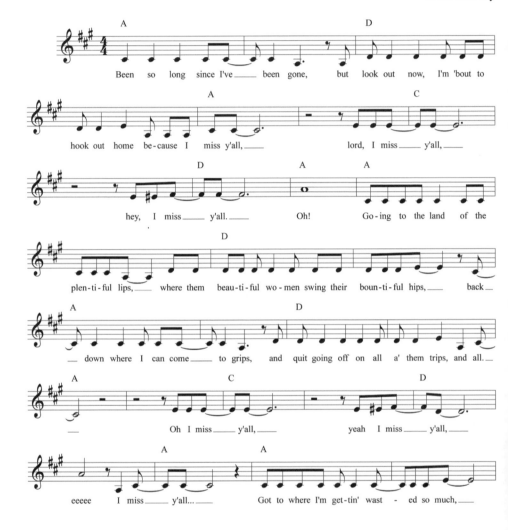

I Miss Y'all

ev - er since the earth - quake I've been in a rut, ___ ev - er since the earth - quake I

been kind 'a nuts, ___ that's why I just had to get ___ back in touch with y'all ___

Hey, I miss ___ y'all, ___ hey, I miss ___ y'all ___ Yeah!

Go-ing to the land of the plen - ti - ful lips, ___ where them beau - ti - ful wo - men swing their

boun - ti - ful hips, ___ back ___ down where I can come ___ to grips, and

quit going off on all a' them trips, and all. ___ Oh I miss ___ y'all, ___

yeah I miss ___ y'all, ___ eeeee I ___ miss y'all... ___

Room to Rock

Words and Music by
Butch Hornsby

2

Room to Rock

I Have Seen the Universe

**Words and Music by
Butch Hornsby**

I Have Seen the Universe

soar-ing through ___ skies, ___ vast ___ dis-tanc-es ___ cuts me down ___ to size. ___

I rode in the Mo-to Cross ___ Ba-by but I lost. ___ I have been torn be-tween ___

___ all I know ___ is all I don't. ___ I have seen the un-i-verse, ___

___ I call it home, ___ it calls me home. ___ I have seen the un-i-verse, ___

___ I call it home, ___ it calls me home. ___ I have seen the un-i-verse, ___

___ I call it home, ___ it calls me home. ___

Suddenly Single

Words and Music by
Butch Hornsby

2

Suddenly Single

been fright - ful, liv-ing a - lone I been sit-tin' here think-ing, ___

since you walked out on me, I must take ad - van-tage ___ of the fact that I'm

free... Sud-den-ly sin-gle, ___ as free as the wind, I'm sure this

ring'll ___ slip right off my hand. I'll go where there's mu-sic, ___

I'll go out with friends, Sud-den-ly I'm sin-gle, ___ I'm sin-gle a - gain.

Dirtdobber Blues

Words and Music by
Butch Hornsby

Dirtdobber Blues

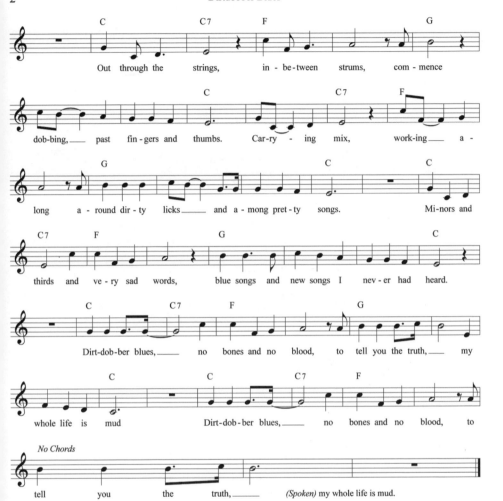

Out through the strings, in - be - tween strums, com - mence dob-bing,___ past fin - gers and thumbs. Car-ry - ing mix, work-ing___ a - long a - round dir - ty licks___ and a - mong pret - ty songs. Mi-nors and thirds and ve - ry sad words, blue songs and new songs I nev - er had heard. Dirt-dob-ber blues,___ no bones and no blood, to tell you the truth,___ my whole life is mud Dirt-dob - ber blues,___ no bones and no blood, to tell you the truth,___ (Spoken) my whole life is mud.

Queen of the Pines

Words and Music by
Butch Hornsby

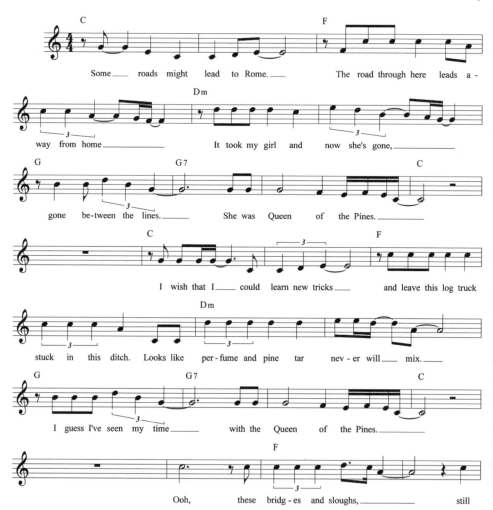

Queen of the Pines

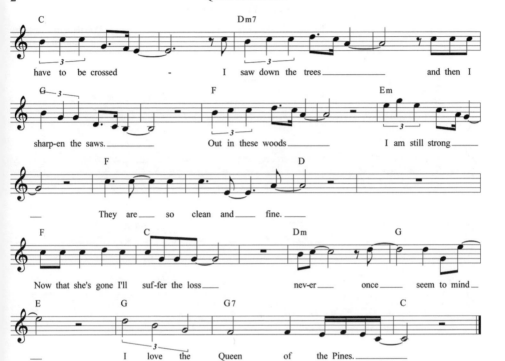

have to be crossed - I saw down the trees_____ and then I

sharp-en the saws._____ Out in these woods_____ I am still strong_____

___ They are___ so clean and___ fine. ___

Now that she's gone I'll suf-fer the loss___ nev-er___ once___ seem to mind___

___ I love the Queen of the Pines._____

Knockin' Around

Words and Music by
Butch Hornsby

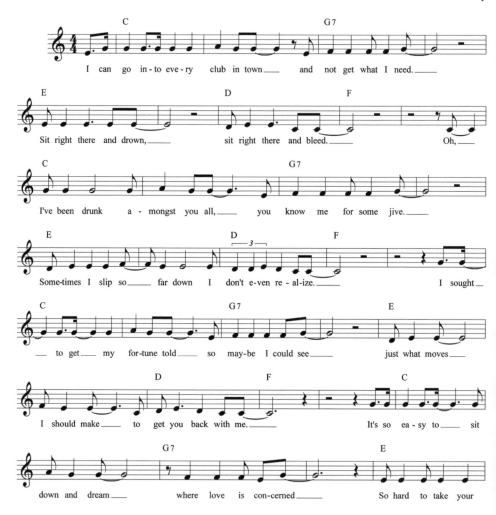

med - i - cine____ once you have been burned.____ And it's

some-thing,____ is it mo-ney____ that mat-ters?____ I've looked all my

life and I've found, I've been dis - sat-is-fied ____ for a long time

now, I've just been knock-in' a - round._____ Well I've

slung big iron for all my life____ and ne - ver____ felt the need,_____ to

drive up in a big____ fine car, pre - tend that I'll____ suc - ceed, and

with-out you____ ev - ery-thing____ is would or should____ or could_____ but

I be - lieve you al____ ways knew____ ex - act - ly where I stood.____

And in the end, it was-n't mo-ney ___ that mat-tered ___

Am D C

I've looked all my life and I've found, Oh, I've been dis-

F C G

sat-is-fied ___ for a long time now, I've just been knock-in' a-round. ___

C C F

___ I've been dis-sat-is-fied ___ for a long time now,

C G C F

I've just been knock-in', ___ yes I've ___ just been knock, knock, knock-in'... ___

C G C

I've just been knock - in' ___ a - round. ___

COLOPHON

This project was conceived and developed by Cyril E. Vetter
for Vetter Communications Corporation in association
with Louisiana State University Press.

NOTES ON THE CD

I produced the Butch Hornsby recordings with Don Chesson, Jr., at Malaco Studios in Jackson, Mississippi, in the early 70s. We had great players on that session like Carson Whitsett, keyboards, James Stroud, drums, Randy Jackson, bass, and Courtney West-brook and Hal Ellis, guitars. I used a Jackson-based gospel group, the Jackson Souther-naires, on backing vocals, and the Memphis Horns on the horn charts.

I produced the Will Kimbrough recordings in Nashville in 2009. Will played all in-struments and sang the lead vocals. I wanted to produce these new versions of Butch's songs as sparely as possible to showcase the poignancy and emotional power of his lyrics.

Duke Bardwell graciously allowed me to use two of his recordings of Butch's songs. Duke and Butch were very close over the years, and he is an important character in the book. (He also produced "Suddenly Single" for RCS in the late 70s.) *"It's Real"* is a studio recording he did in Austin, Texas, at Merle Brigante's studio, with Merle on drums and his studio rhythm section. Duke's live recording of "Dirtdobber Blues" was made on a recent gig in Birmingham, Alabama. I left in Duke's spoken word intro from that performance because he introduces it with a story of how Butch came to write "Dirtdobber Blues." There aren't very many songs written from the POV of an insect, so I thought a little back story would be helpful.

Cyril

ACKNOWLEDGEMENTS

All photographs of Butch's art pieces are by Philip Gould except "Record Bidness," which is courtesy of Shawn Fitzgerald, as is the photograph of Bless Hornsby. ("Record Bidness" was damaged beyond restoration by Katrina so Shawn's image is all that's left.)

"L.A. Oh No!" was provided by William Wright.

"Happier Times At Malaco Studios" was provided by Julie Didier.

Sheet music was prepared by Kenny Kleinpeter.